ALL THE BUILDINGS* IN NEW YORK

제임스 걸리버 핸콕 지음 ㅣ 김문주 옮김

올 더 빌딩스 인 뉴욕

책발전소

뉴욕의 모든 건물 열정의 도시, 뉴욕

나는 호주 시드니에서 자랐다. 시드니는 사방이 탁 트인 도시였고, 나는 매일 해변으로 나가 뜨겁게 달궈진 모래에 발을 지졌다. 재스민 꽃 향기가 도시 사방에서 풍겨왔다. 그러다 보니 뉴욕은 내게 충격적으로 다가왔다. 좋은 의미지만, 어쨌든 충격을 받았다. 나는 많은 곳을 여행하고 다양한 곳에서 살아보았다. 호주에서 영국까지 시베리아 횡단 급행열차를 타고 여행도 했다. 그리고 파리와 빈, 베를린, 런던, 로스앤젤레스, 몬트리올, 그리고 인도네시아에서 살았다. 나는 세계 각국에 내 자취를 남기고 도시의 느낌을 표현하려고 그림을 그린다.

모든 여정에서 나는 각 장소를 특별하게 하는 세세한 부분에 매료되었다. 서로를 구분 짓는 작고 사소한 것, 일상적인 물건과 관습 같은 것이었다. 나는 어떤 장소를 정의 내리는 것은 커다란 무언가가 아닌, 작고 일상적인 차이라고 느끼기 시작했다. 어딘가를 그리워하도록 하는 것은 언어나 관광 명소가 아니었다. 일상에서 주변을 둘러보면 볼

수 있는 것이었다. 인도네시아에서는 독특하게 콘크리트가 쌓여있으며, 런던에서는 길거리와 건물이 독특하게 조화를 이룬다. 또 일본에서는 타일이 독특한 모양으로 가로누워 있다.

그렇게 나는 매료되었다. 다시 말하자면, 사로잡혔다. 여행하면서 발견하는 일상의 세세한 구석은 그 장소를 이해할 수 있게 도와주었다. 무엇보다도 '파리의 모든 지붕', '베를린의 모든 자전거', '런던의 모든 비', '로스앤젤레스의 모든 차' 그리고 '몬트리올의 모든 눈'을 기록하려고 소소하게 시도해보기도 했다. 그리고 마침내 내가 이 세상에서 가장 멋진 도시 뉴욕으로 향하면서 이 시도는 새롭게 추진력을 얻었다.

뉴욕에 처음 온 사람은 뉴욕을 가지고 싶어 한다. 그리고 이곳에서 살지 못했던 시간을 만회하고 싶어 한다. 나 또한 그렇게 하고 싶었기에 주변을 그림으로 그렸다. 그렇게 하면서 새로운 도시에 더욱 파고들고 연을 맺었다. 많은 사람이 뉴욕을 찾아오고 사랑에 빠진다. 나를

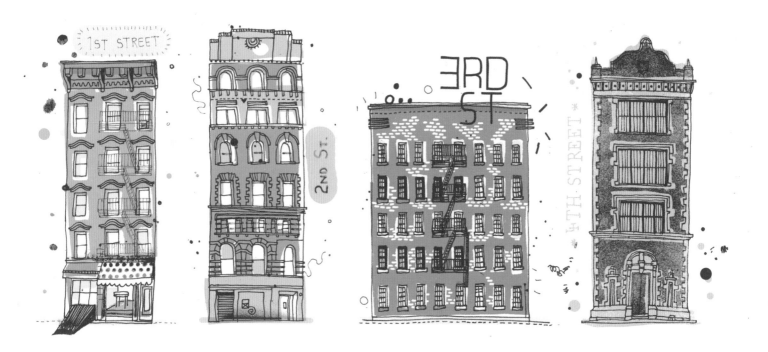

뉴욕과 사랑에 빠뜨린 것은 그 도시가 주는 농밀한 경험이었다. 뉴욕은 격자로 잘 짜여진, 무질서하고 엉망진창이면서도 역사적이고 유기적인 도시이다. 크라이슬러 빌딩이나 자유의 여신상 같은 완벽한 건축물이 '아이 러브 뉴욕'을 상징한다. 하지만 진정한 뉴욕의 삶과 열정을 지지하는 것은 빽빽한 일상과 함께 존재하는 평범한 건물이다. 뉴욕의 아이콘 곁에 바싹 서 있는 이러한 건축물이야말로 이 도시를 특별하게 만드는 존재들이다.

이러한 그림 작업은 나에게 의식과도 같으며, 일종의 치유이다. 이를 통해 나는 뉴욕이 주는 압도적인 무한의 공간과 무질서를 이해할 수 있었다. 어떤 때는 그린 건물들이 테트리스 게임처럼 서로 꼭 들어맞으면서 어울리다가, 다른 때는 엉망진창으로 보이기도 했다. 일기를 기록하는 일과 같은 이 과정은 내 마음을 다스리는 데 도움을 주었다. 그리고 완전히 무질서한 뉴욕이 점차 친근하게 바뀌면서, 내 도시가 되었다.

뉴욕에 도착했을 때 희한하게도 모든 것이 익숙했다. 아마도 자라면서 TV와 영화를 통해 모습을 접했기 때문일 것이다. 또한 내 최초의, 그리고 가장 로맨틱한 시각적 기억 역시 뉴욕과 관련이 있다. 나는 처음 뉴욕으로 이사해서 브루클린에 살았다. 브루클린 길거리는 애니메이션 〈세서미 스트리트〉에 나오는 거리와 완전히 똑같았다. 당장이라도 쓰레기통에서 사는 오스카가 튀어나오지 않을까 기대할 지경이었다. 그리고 이것이 전부가 아니었다. 또 다른 동네에서는 더 많은 기억이 떠올랐다. 어퍼웨스트사이드에서는 영화 〈웨스트 사이드 스토리〉

가, 그리니치빌리지 에서는 〈이창〉이, 5번가에서는 〈티파니에서 아침을〉이, 센트럴 파크 주변의 아름다운 빌딩들에서는 〈고스트버스터즈〉가, 베드퍼드스타이베선트에서는 〈똑바로 살아라〉가, 그리고 맨해튼에서는…〈맨해튼〉이 생각났다.

나는 뉴욕의 모든 것을 아는 것 같았다. 도시의 길거리, 지하철, 비상계단, 소화전 등이 친숙했다. 그러나 이 모습은 카메라를 통해서 보고 느낀 것이었다. 그렇기에 영화 세트장 뒤에서 존재한 뉴욕을 진정으로 이해할 수도 그리고 공감할 수도 없었다.

그래서 나는 "All The Buildings In New York"이라는 프로젝트를 시작했다. 이 프로젝트는 지금까지 진부하던 뉴욕을 잊고 유대감을 느끼는 방법이었다. 나에게 그리는 것은 자연스레 나오는 행동이다. 그래서 도시 주변에 있는 복잡한 모습을 그림으로 표현하는 기발한 계획이 떠올랐다. 세세하게 묘사한 모든 건물, 창문, 굴뚝, 수도관, 그리고 관 사이사이에 쳐진 모든 거미줄까지. 상투적인 표현에서 벗어나 이 장엄한 도시를 혼자 재배치하기 시작했다. 이제 나는 그림으로 그려낸 건물 사이를 누비며 마치 오랜 친구를 만난 듯 반가워한다.

그림은 주변 사물을 이해하려는 나만의 방식이다. 그렇게 나는 뉴욕을 편안하고 친근하게 생각한다. 이 프로젝트를 통해 뉴욕과 친구가 되었다. 당신에게도 마찬가지이기를 바란다. 이 책은 일종의 가이드북이지만 컬러링북이다. 뉴욕 구석구석을 보면서 당신이 느낀 감정을 색으로 표현해보자. 프로젝트는 앞으로도 계속된다. 그 여정이 궁금하다면 www.allthebuildingsinnewyork.com 을 방문하길 바란다.

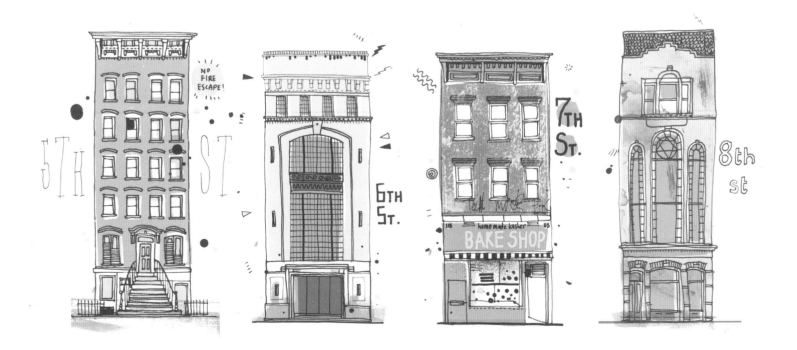

COMPLETED IN 1812
DESIGNED BY
JOSEPH-FRANÇOIS MANGIN
&
JOHN McCOMB Jr.

OLDEST CITY HALL IN THE U.S.A.
STILL BEING USED FOR GOVERNMENT
FUNCTIONS LIKE THE MAYOR'S OFFICE

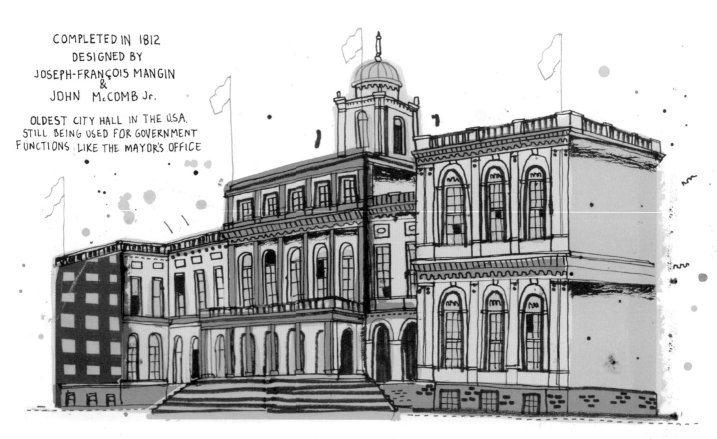

CITY HALL

COMPLETED IN 1812
DESIGNED BY
JOSEPH-FRANÇOIS MANGIN
&
JOHN McCOMB Jr.

OLDEST CITY HALL IN THE U.S.A.
STILL BEING USED FOR GOVERNMENT
FUNCTIONS LIKE THE MAYOR'S OFFICE

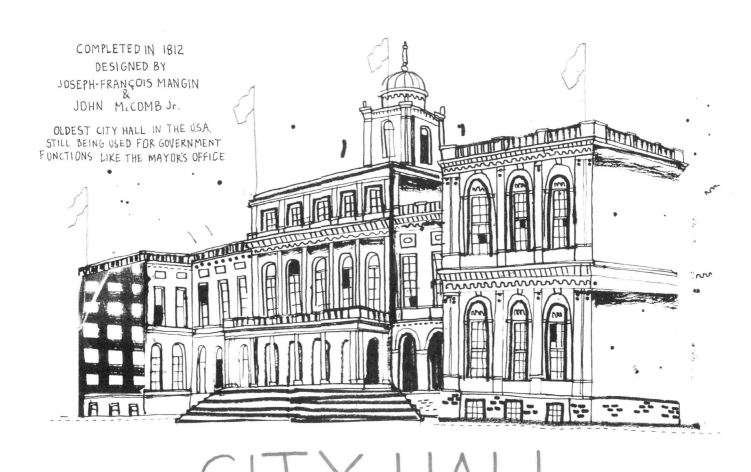

CITY HALL

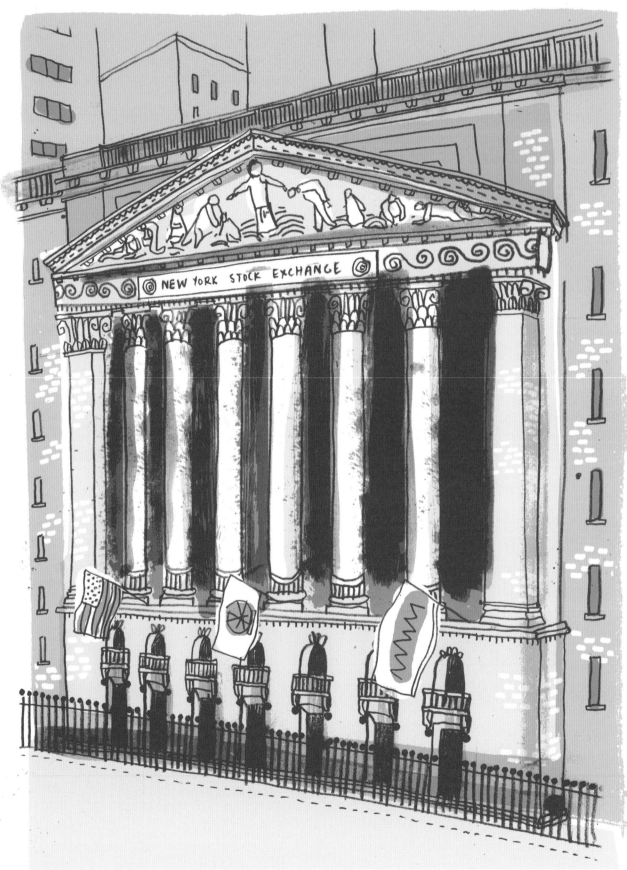

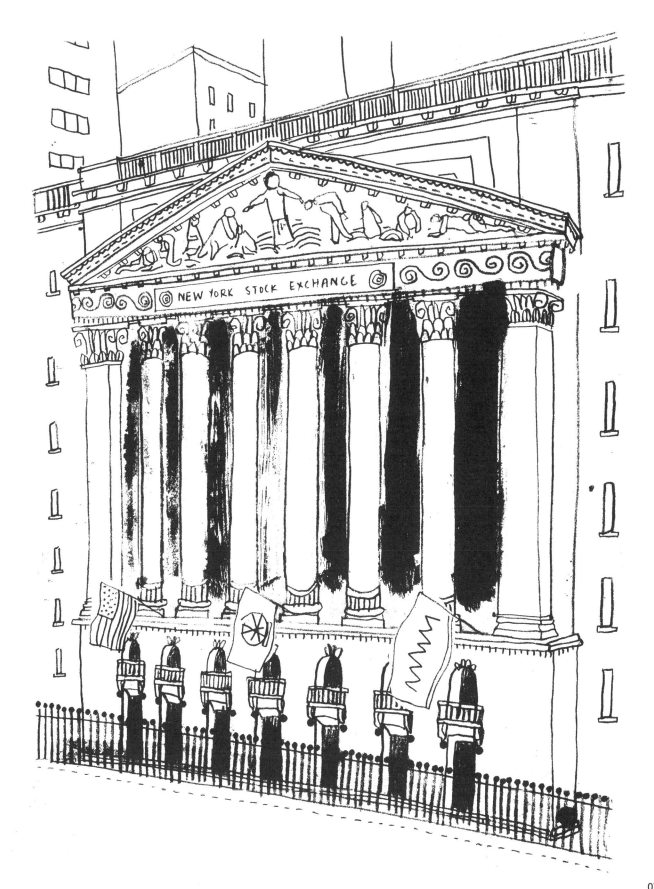

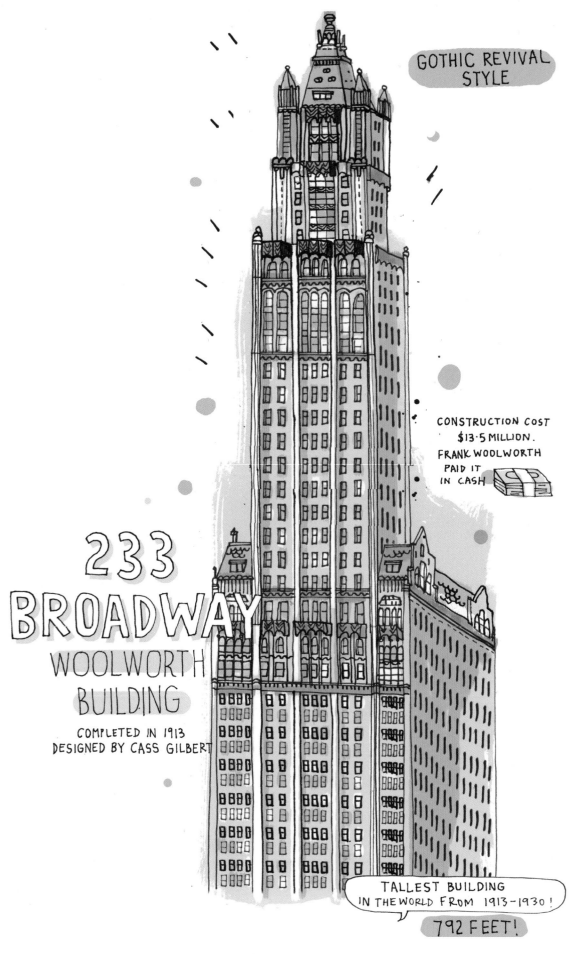

GOTHIC REVIVAL STYLE

CONSTRUCTION COST $13.5 MILLION. FRANK WOOLWORTH PAID IT IN CASH

233 BROADWAY
WOOLWORTH BUILDING
COMPLETED IN 1913
DESIGNED BY CASS GILBERT

TALLEST BUILDING IN THE WORLD FROM 1913-1930!

792 FEET!

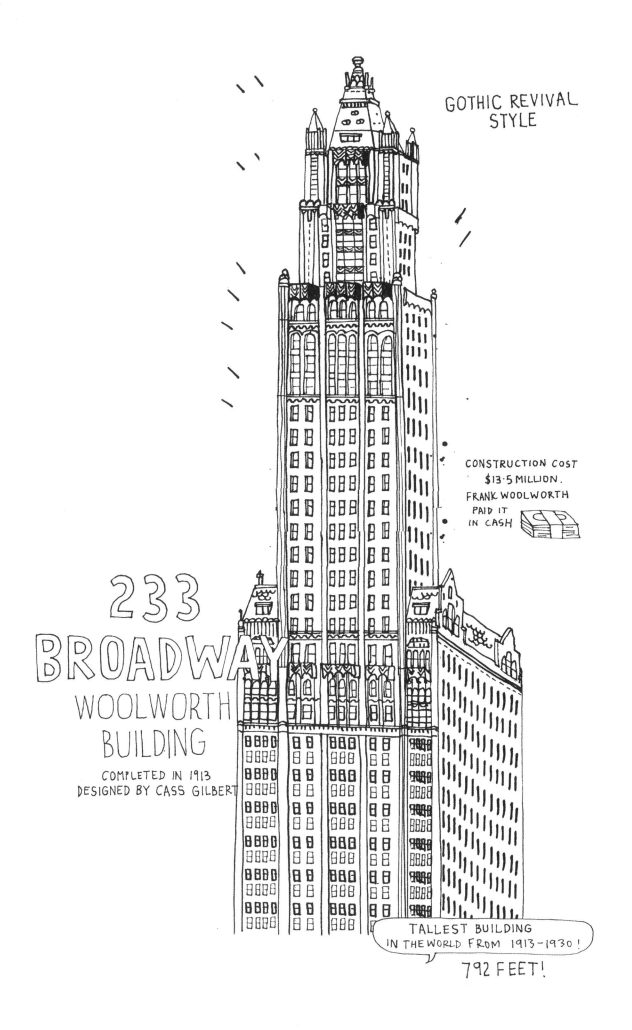

GOTHIC REVIVAL STYLE

CONSTRUCTION COST $13·5 MILLION. FRANK WOOLWORTH PAID IT IN CASH

233 BROADWAY WOOLWORTH BUILDING

COMPLETED IN 1913 DESIGNED BY CASS GILBERT

TALLEST BUILDING IN THE WORLD FROM 1913-1930!

792 FEET!

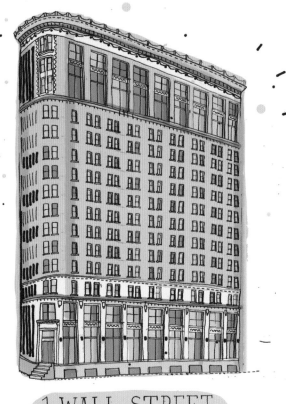

1 WALL STREET
COURT

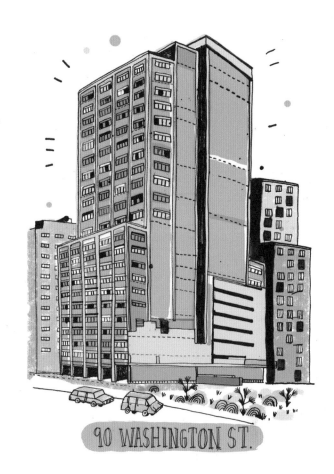

90 WASHINGTON ST.

75
WALL
STREET

1 WEST STREET

1 WALL STREET
COURT

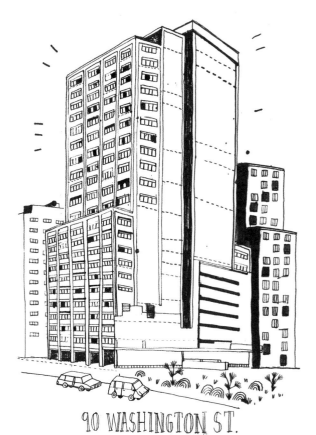

90 WASHINGTON ST.

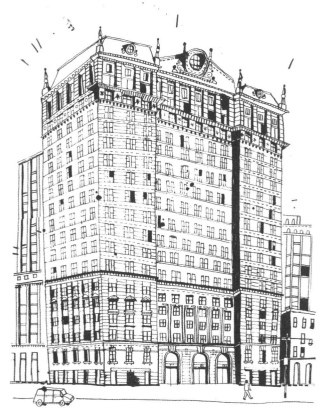

1 WEST STREET

75
WALL
STREET

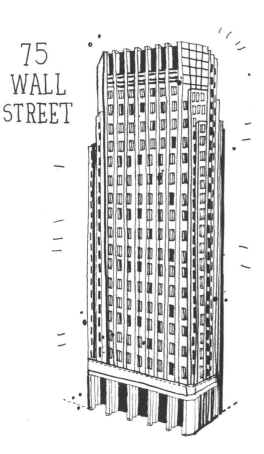

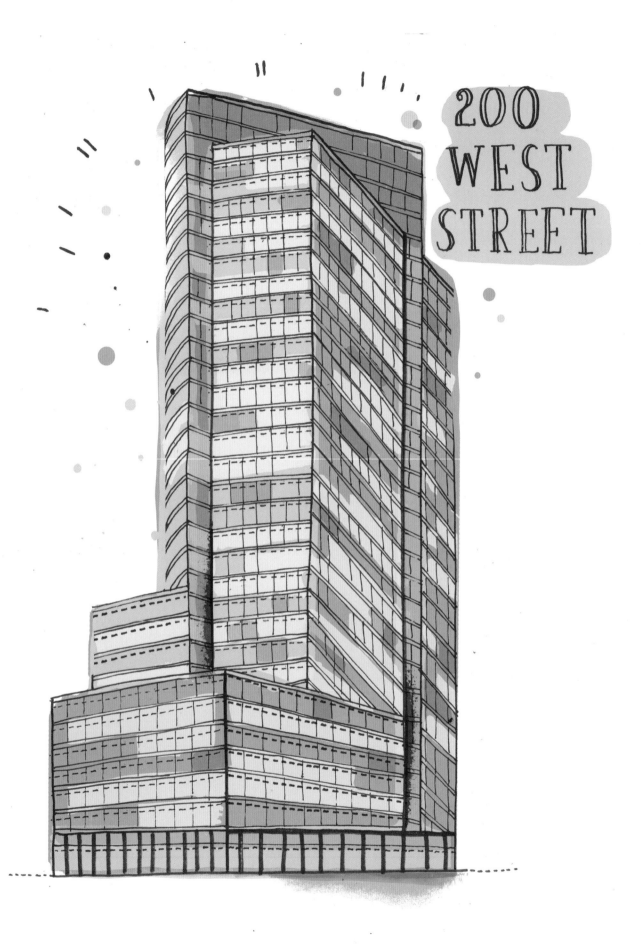

200
WEST
STREET

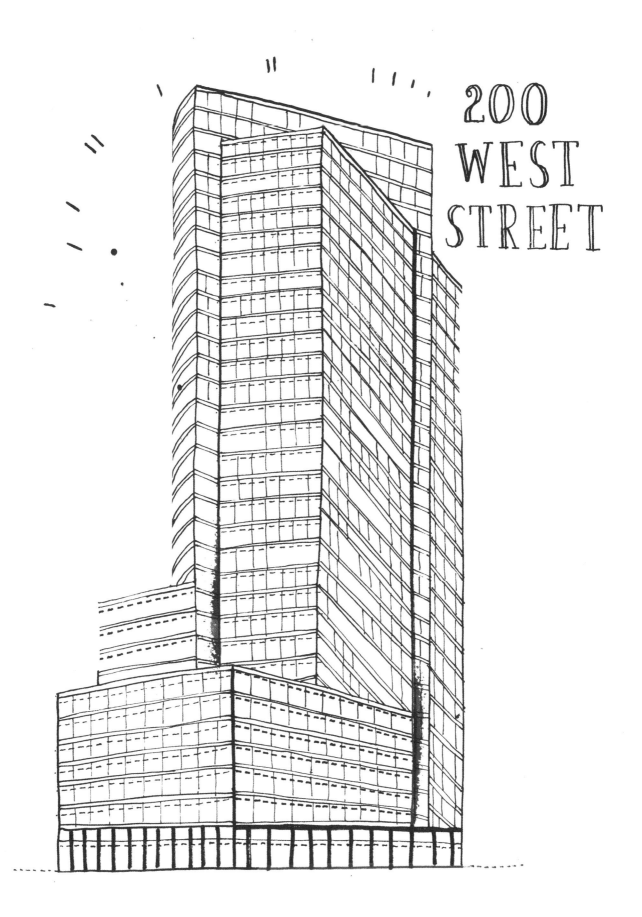

200
WEST
STREET

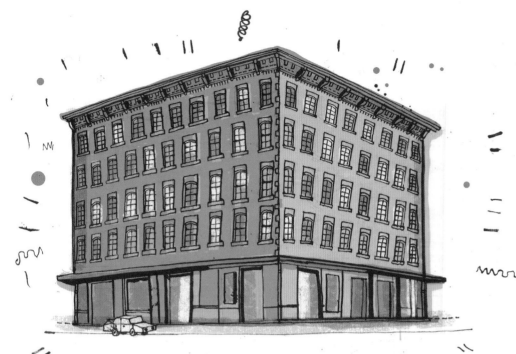

62 BEACH STREET

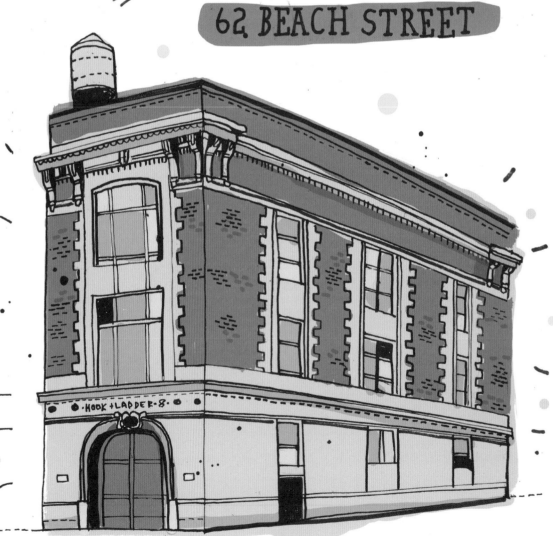

14 NORTH MOORE ST. HOOK & LADDER 8
(WHERE THEY FILMED GHOSTBUSTERS!)

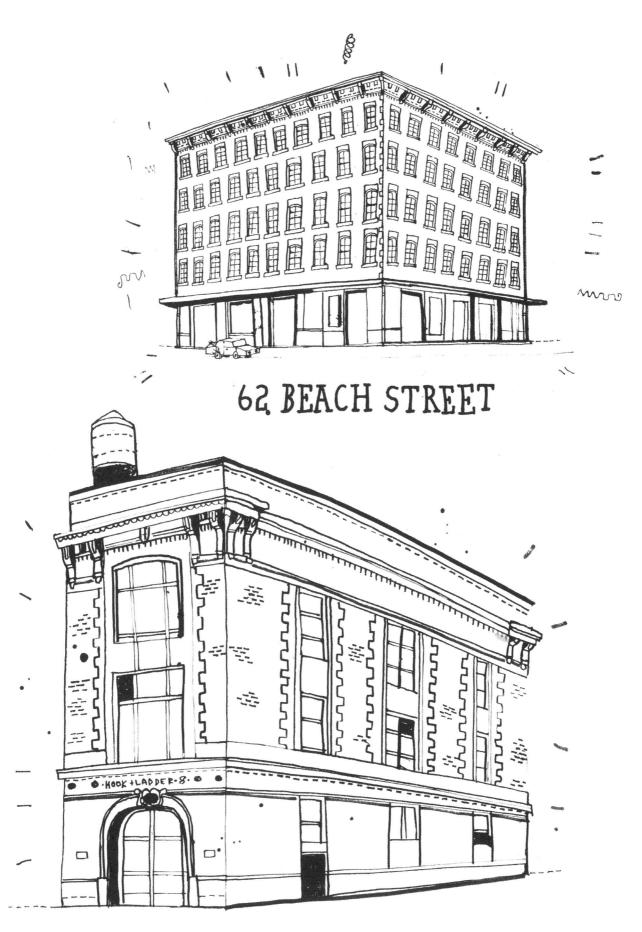

62 BEACH STREET

14 NORTH MOORE ST. HOOK & LADDER 8
(WHERE THEY FILMED GHOSTBUSTERS!)

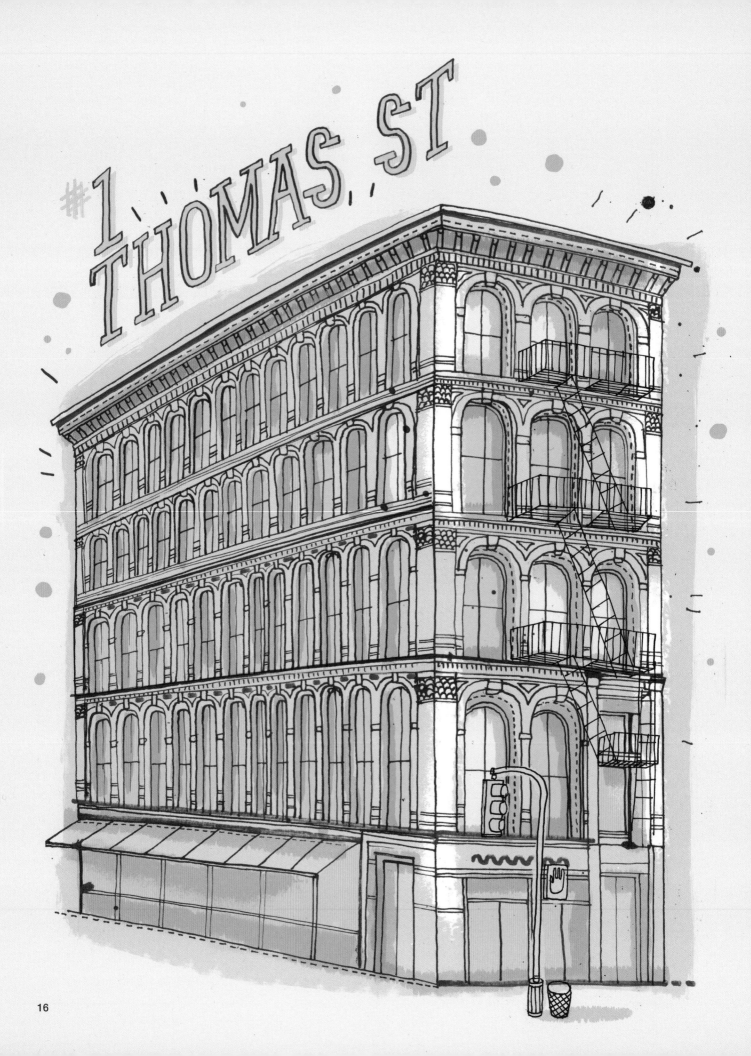

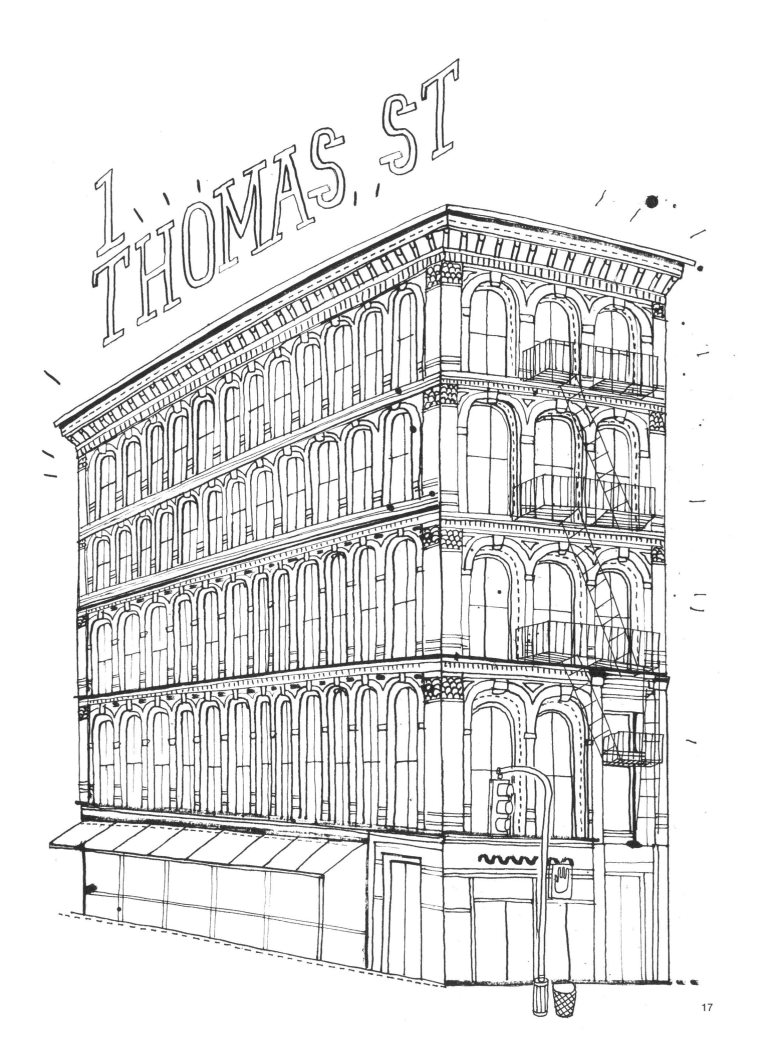

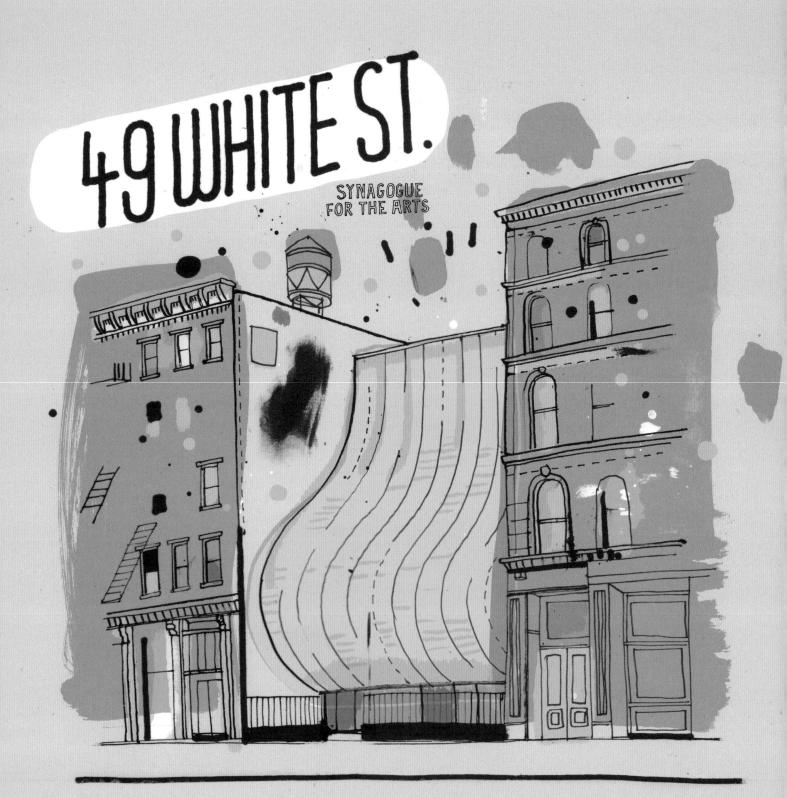

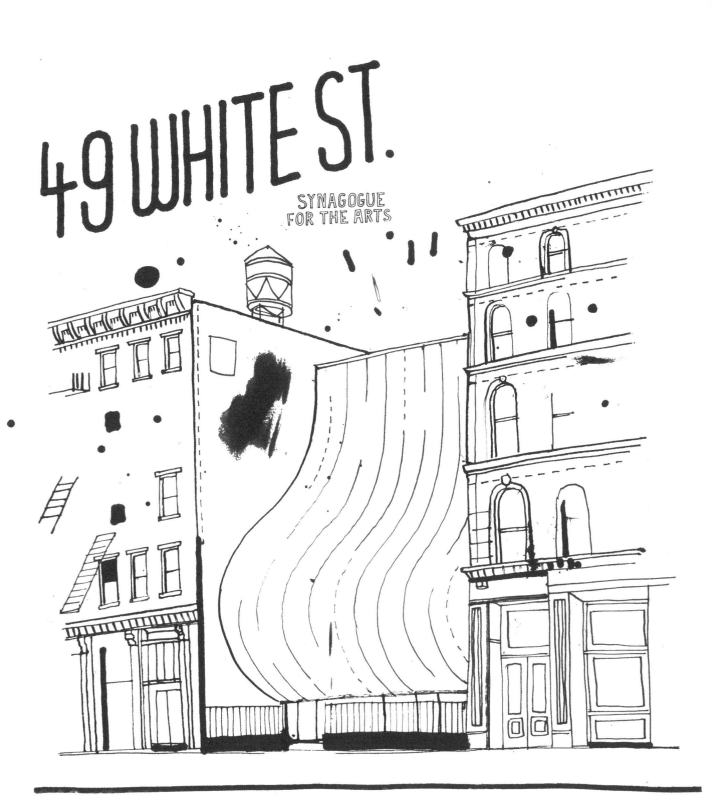

83 MOTT ST

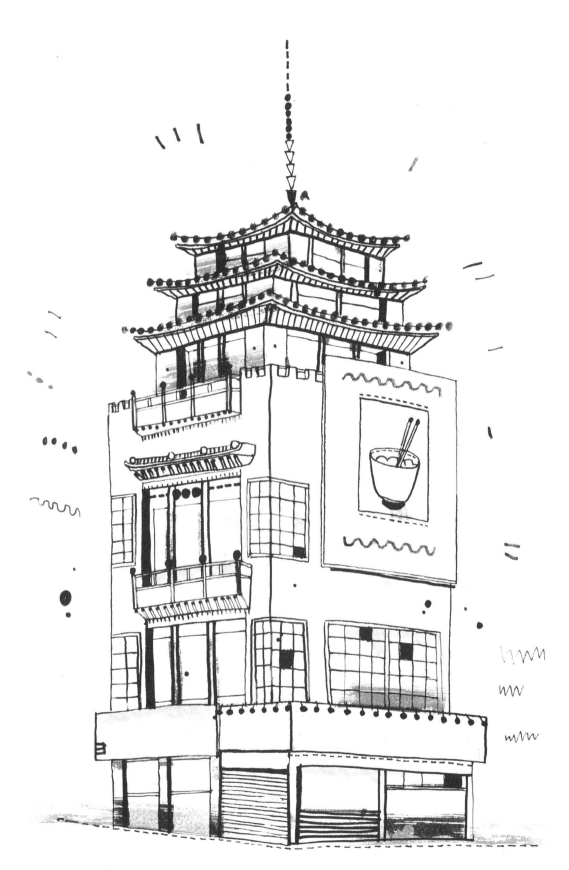

83 MOTT ST

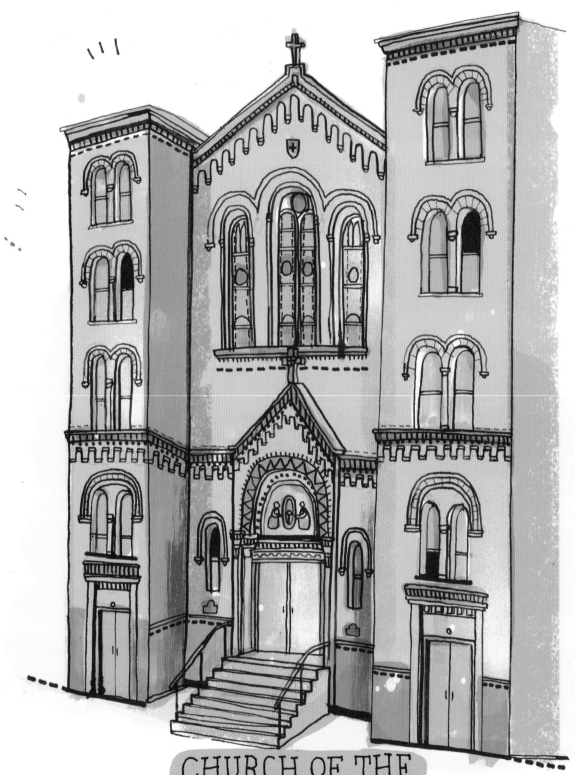

CHURCH OF THE
MOST PRECIOUS BLOOD
109 MULBERRY ST

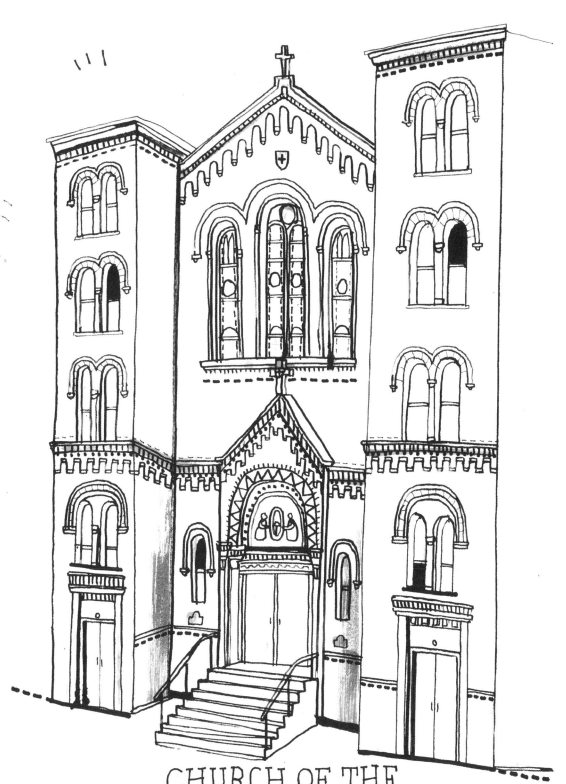

CHURCH OF THE
MOST PRECIOUS BLOOD
109 MULBERRY ST

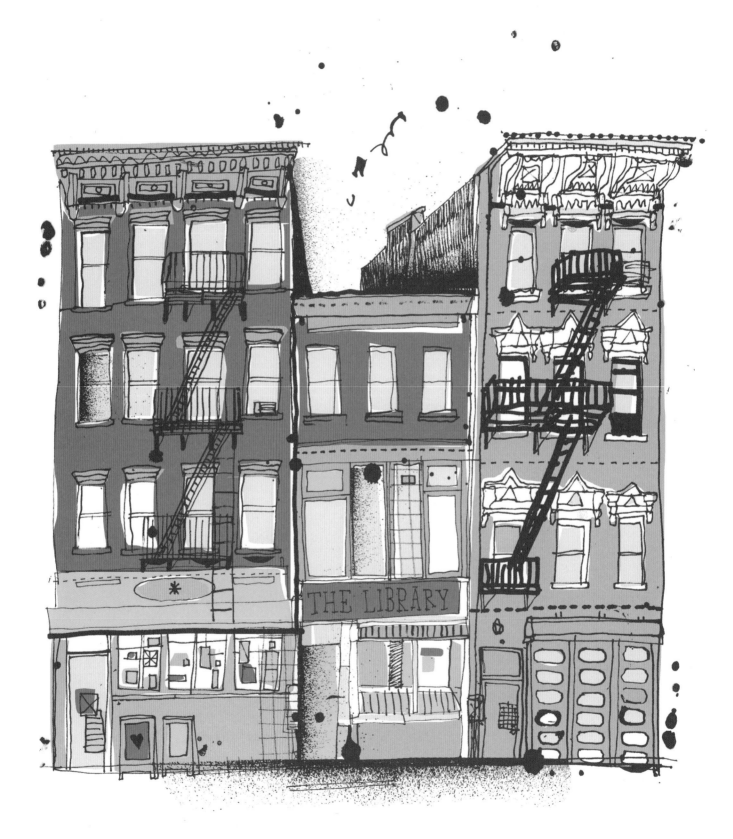

THE LIBRARY

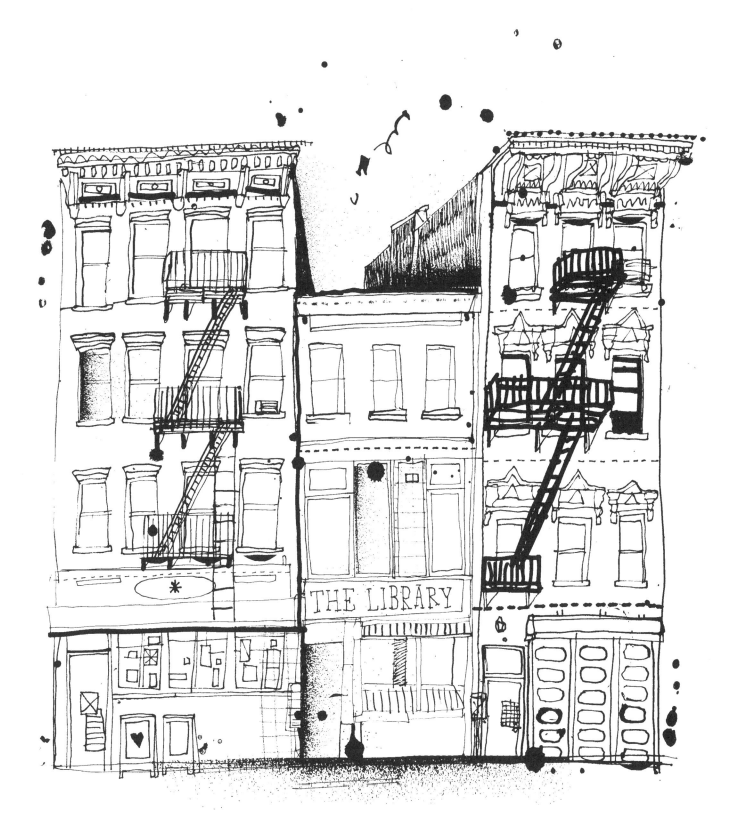

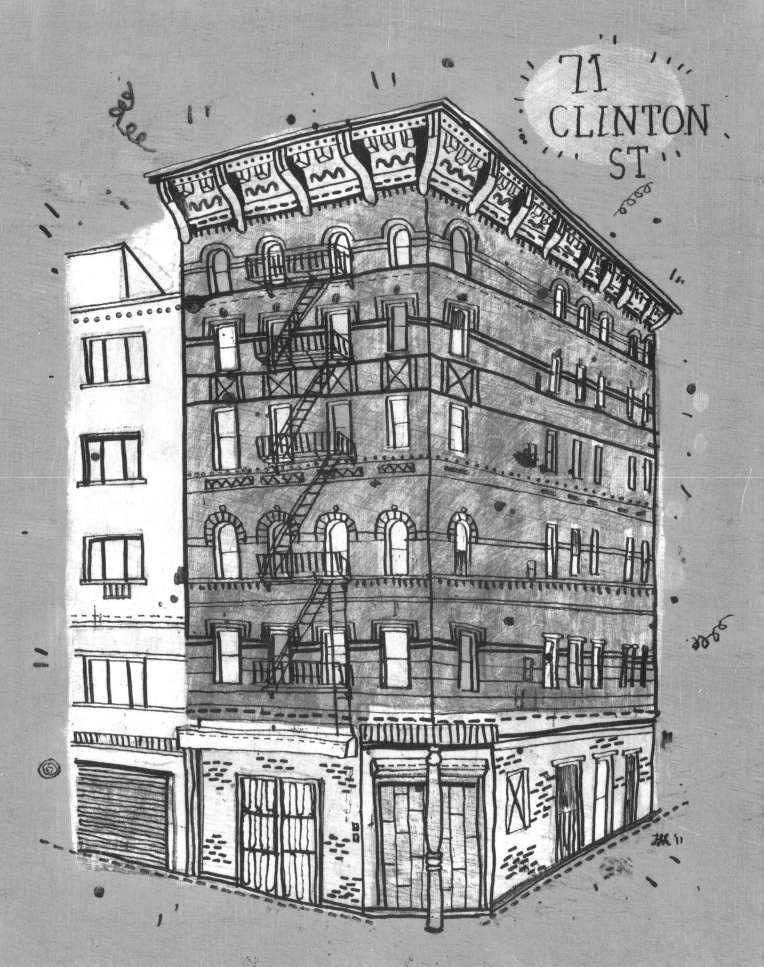

71
CLINTON
ST

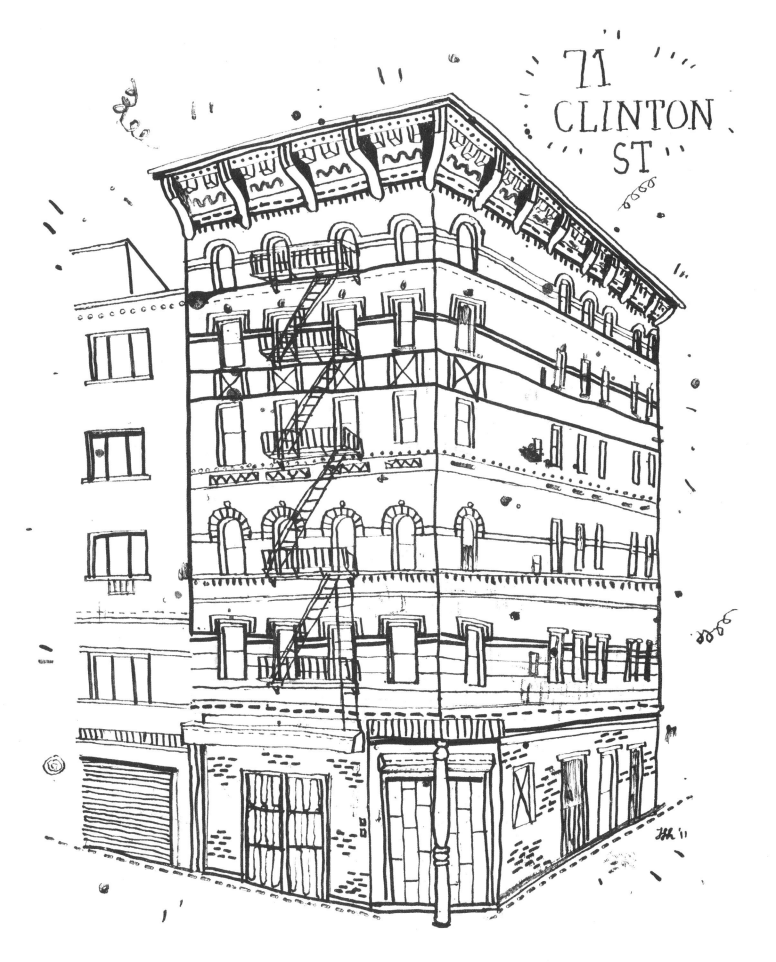

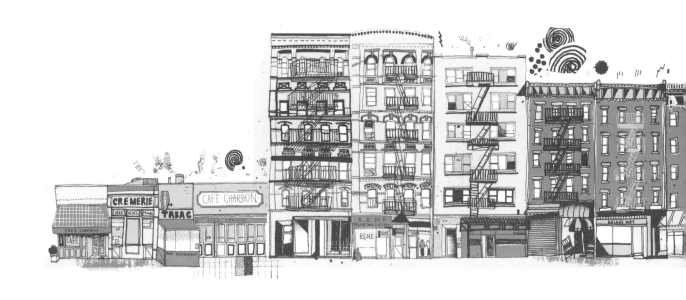

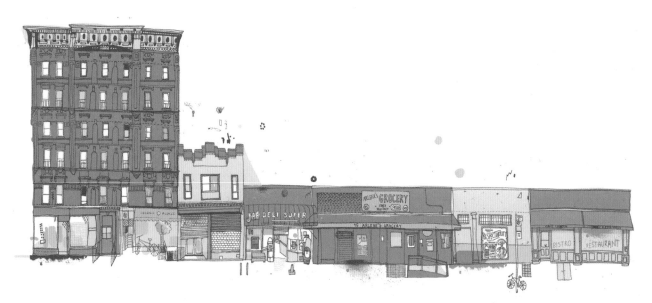

STANTON ST

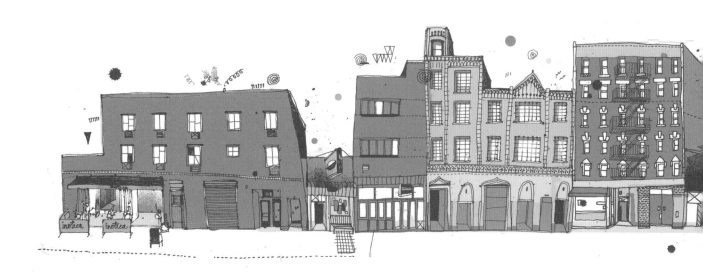

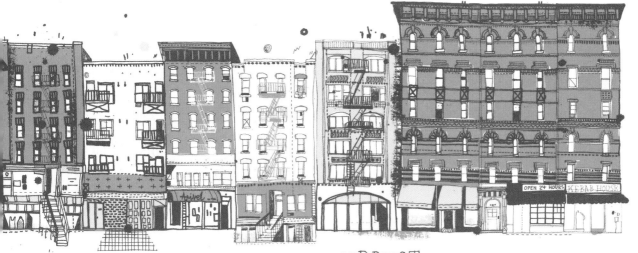

ORCHARD ST.

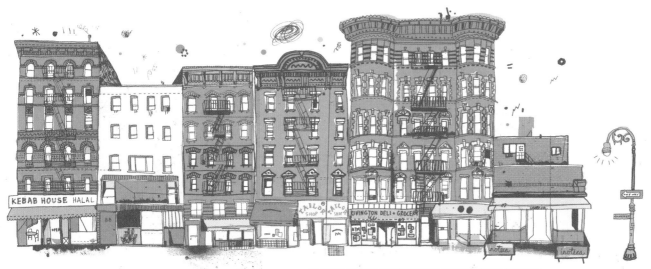

RIVINGTON ST

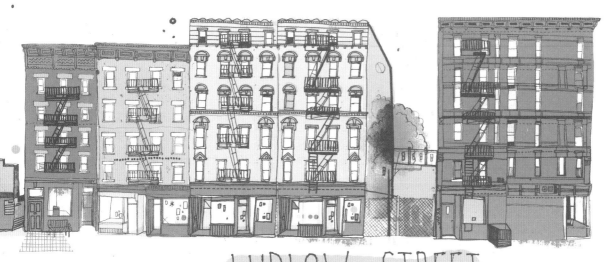

LUDLOW STREET

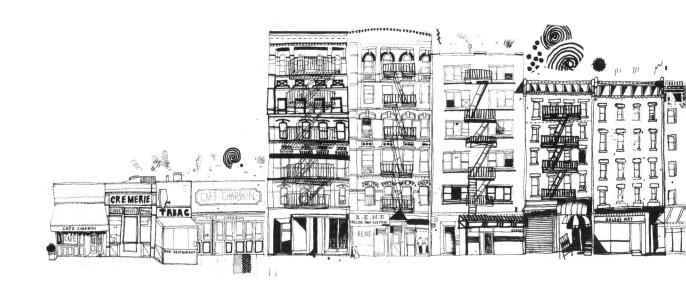

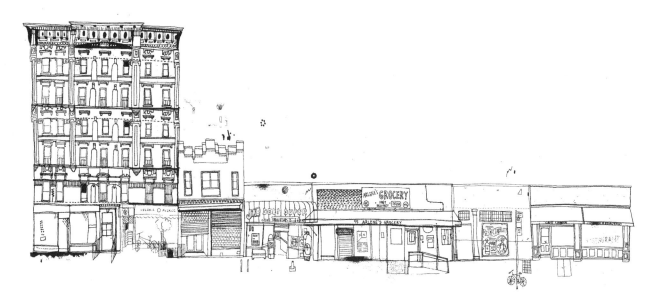

STANTON ST

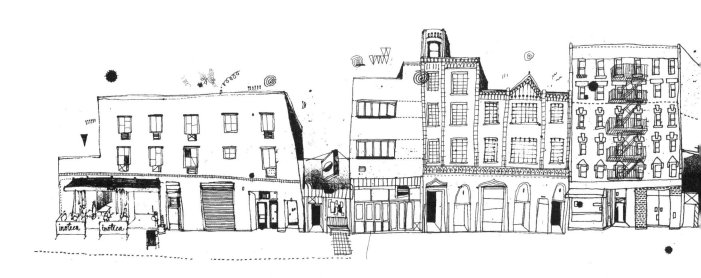

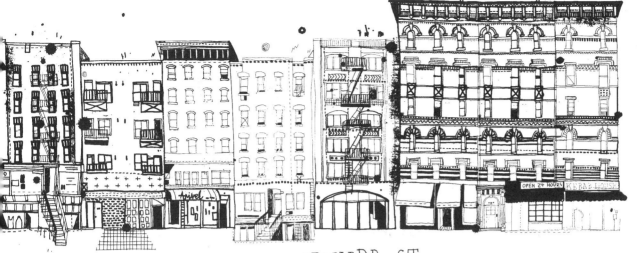

ORCHARD ST.

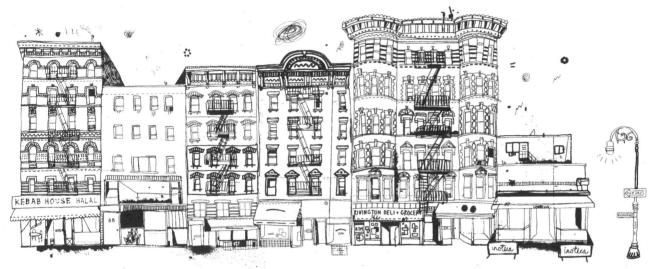

RIVINGTON ST

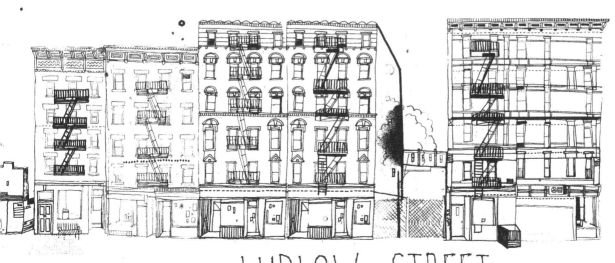

LUDLOW STREET

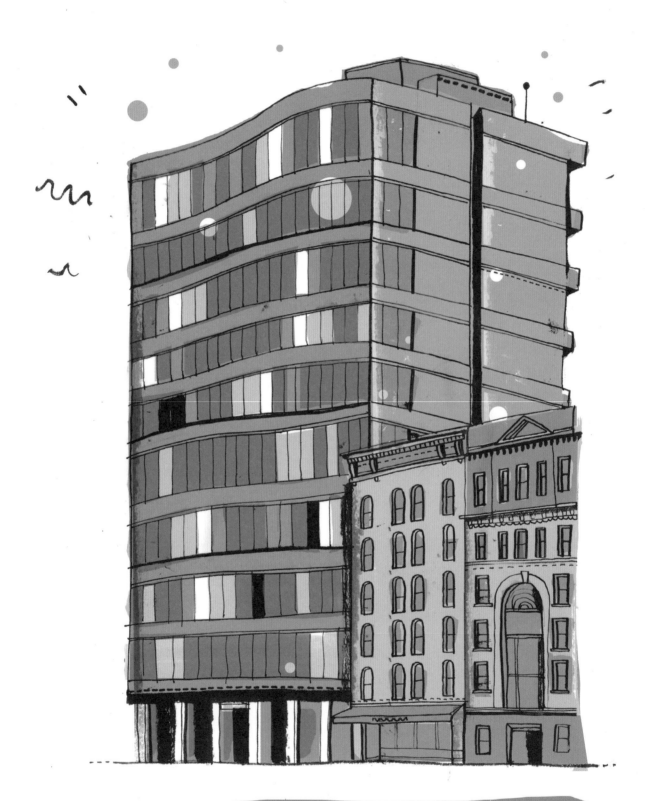

210 LAFAYETTE ST

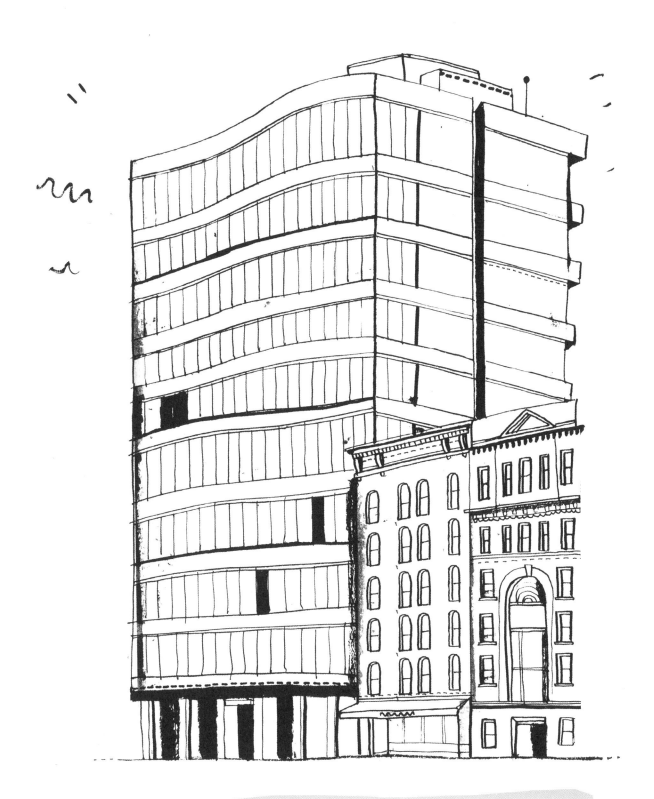

210 LAFAYETTE ST

PUCK BUILDING
295 LAFAYETTE ST.

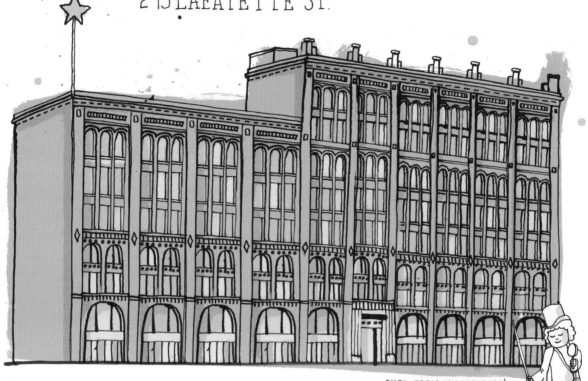

PUCK FROM SHAKESPEARE'S
A MIDSUMMER NIGHT'S DREAM
ADORNS THE BUILDING

22 MERCER STREET

136 BAXTER ST

PUCK BUILDING
295 LAFAYETTE ST.

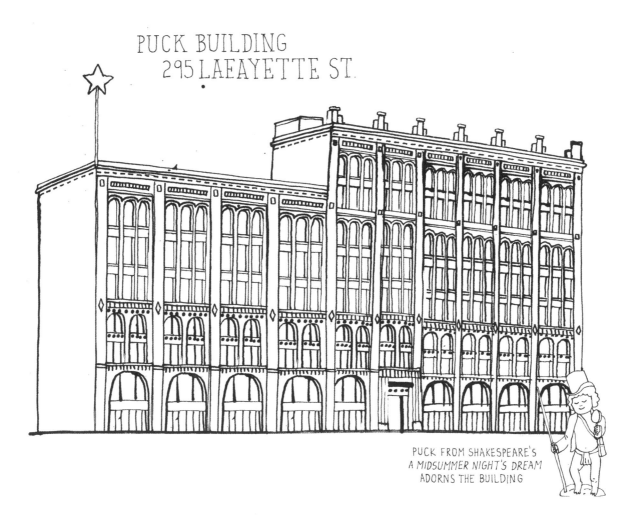

PUCK FROM SHAKESPEARE'S
A MIDSUMMER NIGHT'S DREAM
ADORNS THE BUILDING

22 MERCER STREET

136 BAXTER ST

58 CHARLES ST

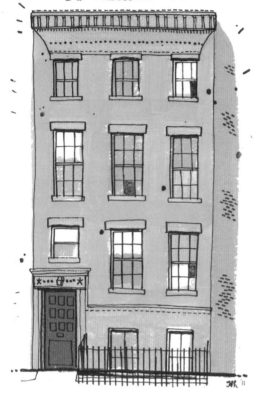

75 ½ BEDFORD ST

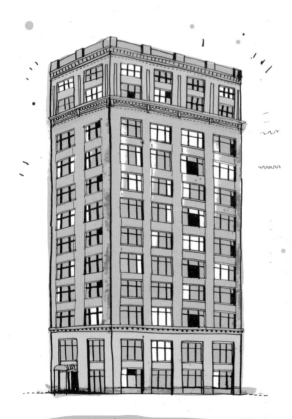
147 WAVERLY PLACE

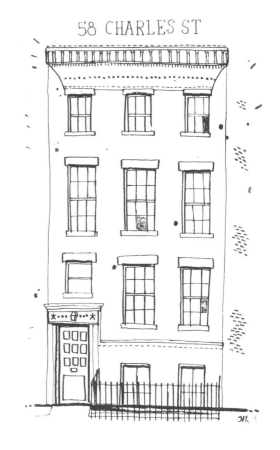

58 CHARLES ST

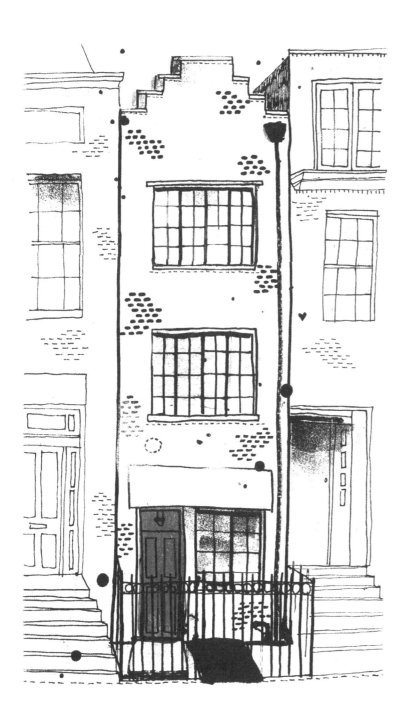

75½ BEDFORD ST

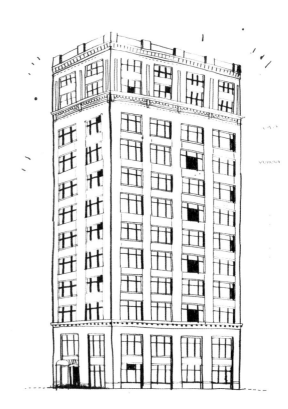

147 WAVERLY PLACE

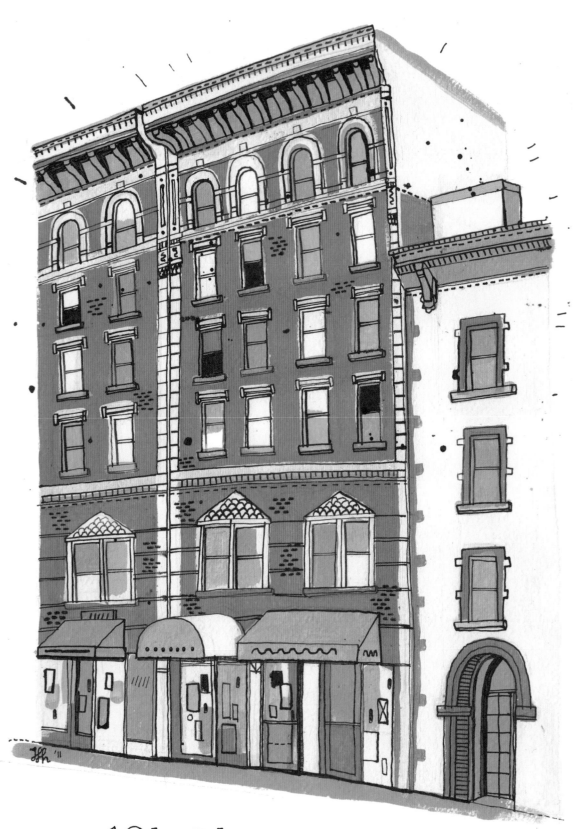

794 BLEECKER ST.

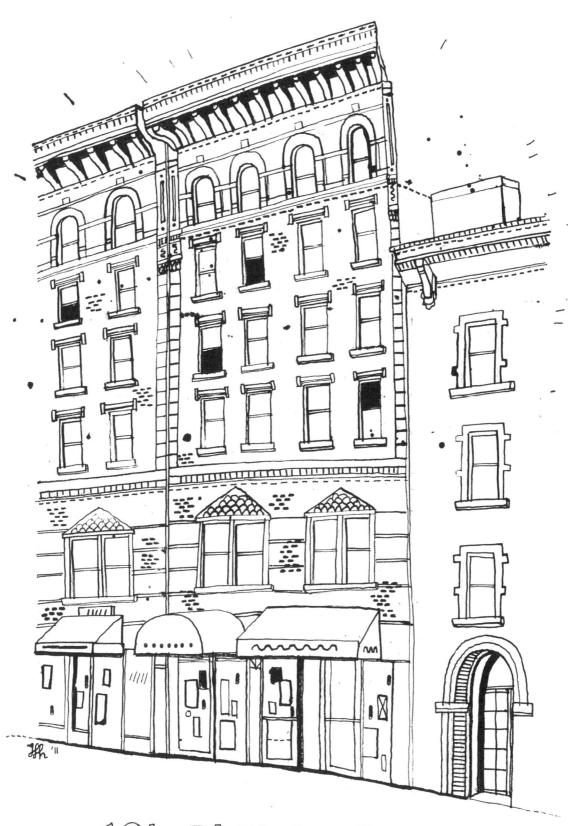

794 BLEECKER ST.

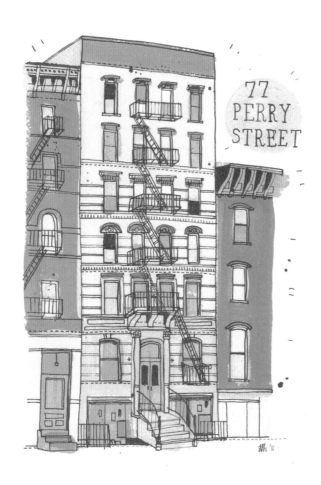

77 PERRY STREET

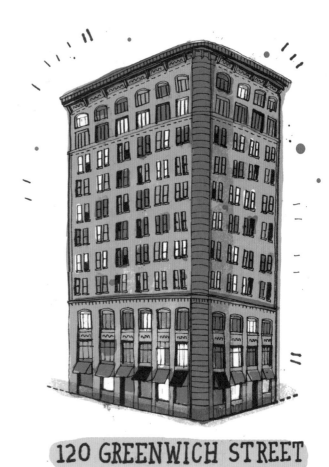

120 GREENWICH STREET

45 HORATIO STREET

1 MORTON SQUARE

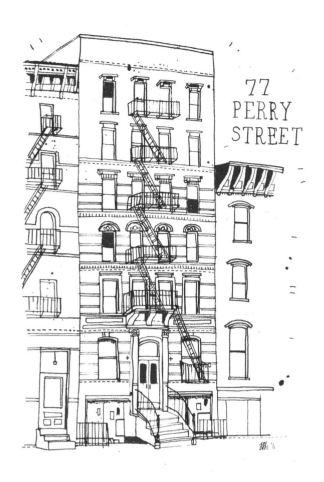

77
PERRY
STREET

120 GREENWICH STREET

45 HORATIO STREET

1 MORTON SQUARE

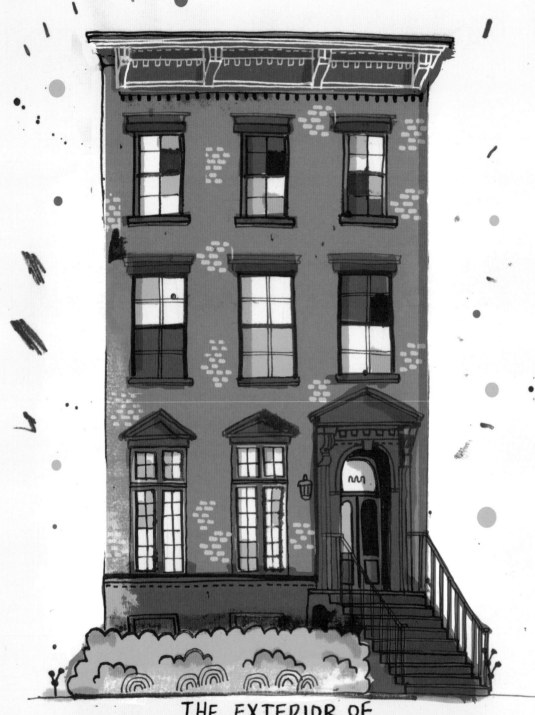

THE EXTERIOR OF

THE COSBY HOUSE

10 ST. LUKE'S PLACE

(BUT IN TV LAND THIS HOUSE WAS IN BROOKLYN)

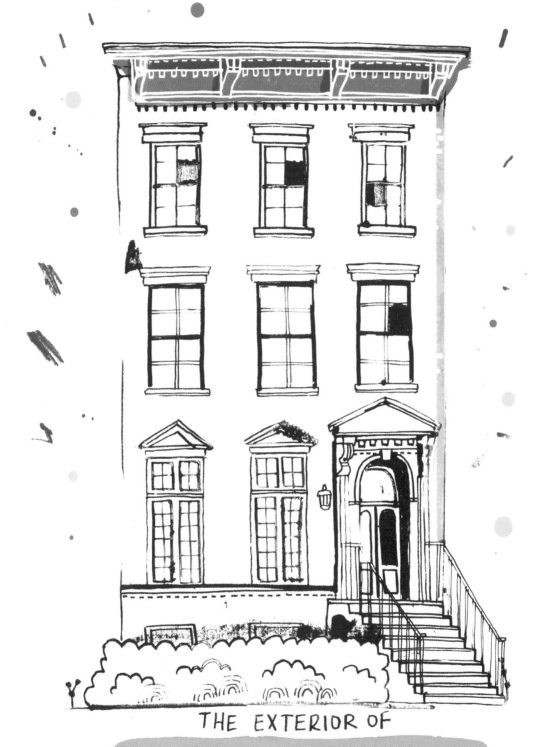

THE EXTERIOR OF

THE COSBY HOUSE

10 ST. LUKE'S PLACE

(BUT IN TV LAND THIS HOUSE WAS IN BROOKLYN)

56 JANE ST

55 WEST 8th. STREET

8 EAST 8th. STREET

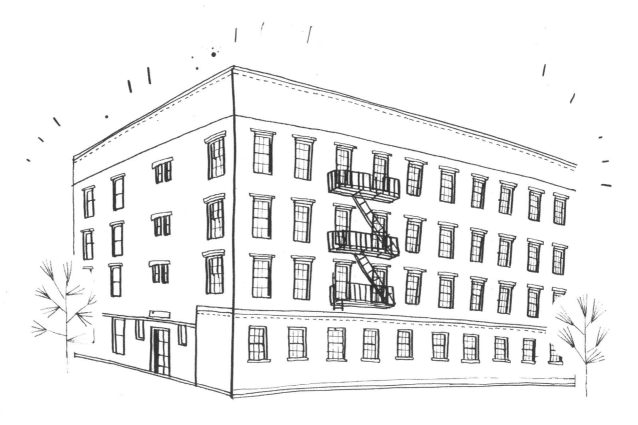

56 JANE ST

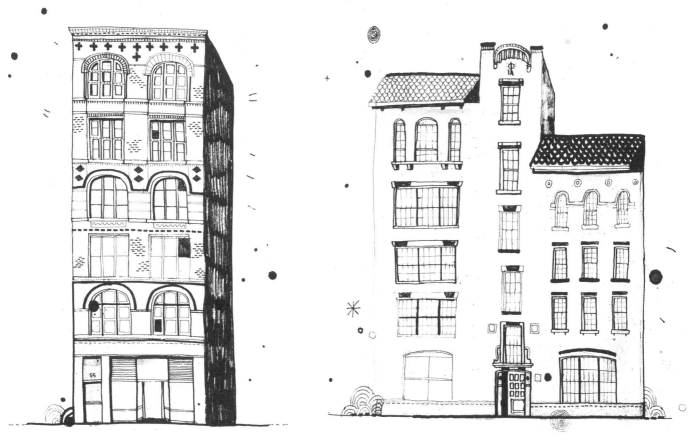

55 WEST 8th. STREET

8 EAST 8th. STREET

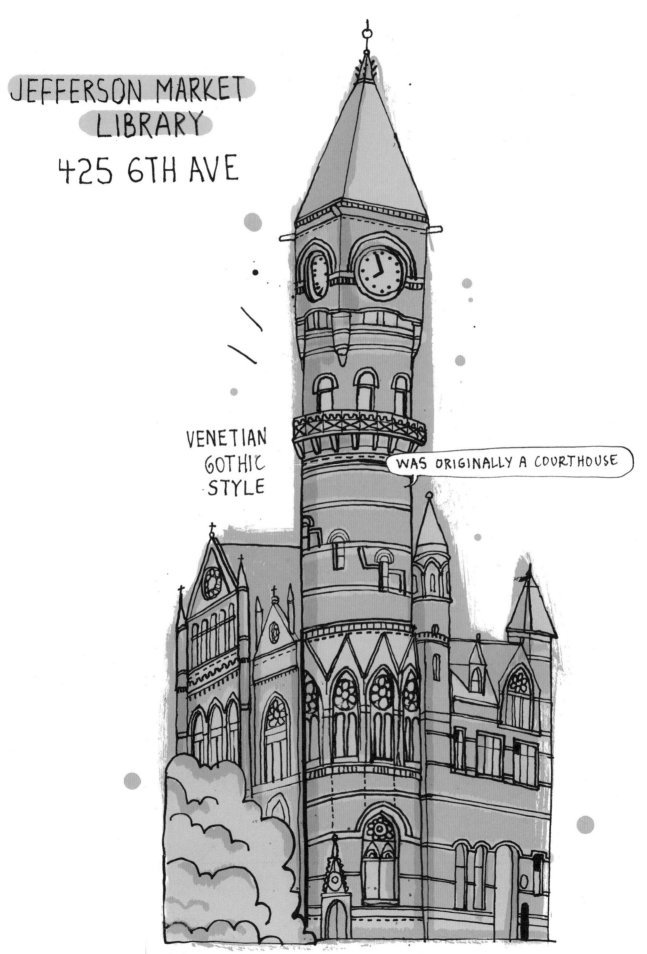

JEFFERSON MARKET
LIBRARY
425 6TH AVE

VENETIAN
GOTHIC
STYLE

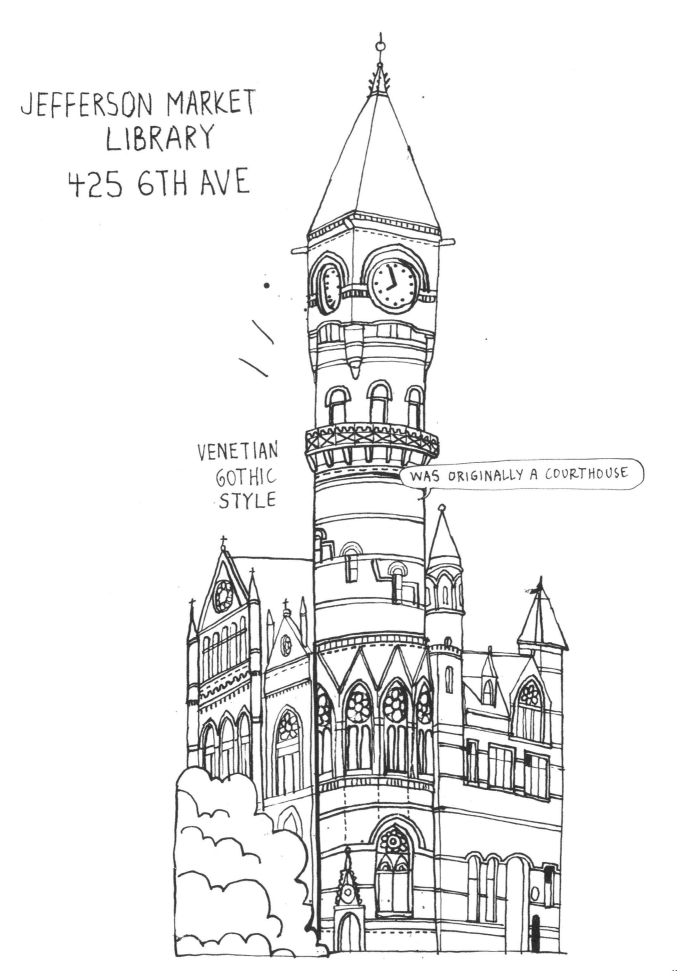

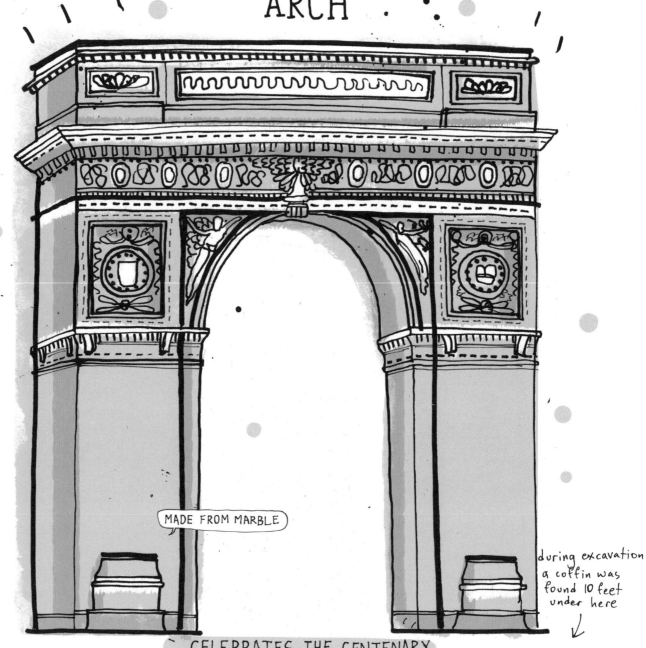

WASHINGTON SQUARE ARCH

MADE FROM MARBLE

CELEBRATES THE CENTENARY OF GEORGE WASHINGTON BECOMING PRESIDENT.

during excavation a coffin was found 10 feet under here

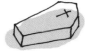

WASHINGTON SQUARE ARCH

MADE FROM MARBLE

CELEBRATES THE CENTENARY
OF GEORGE WASHINGTON
BECOMING PRESIDENT.

during excavatio
a coffin was
found 10 feet
under here

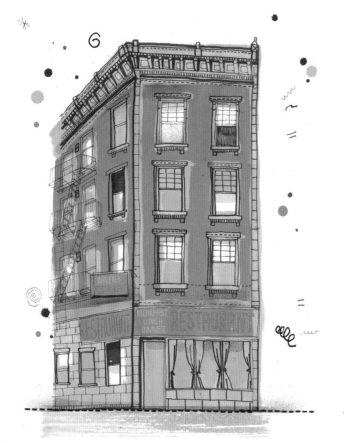

385 6th AVENUE

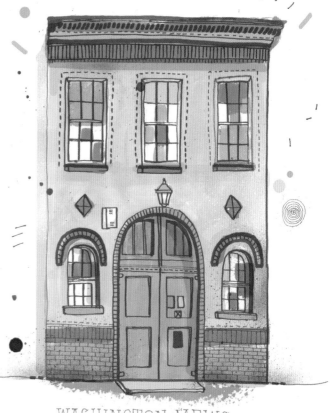

WASHINGTON MEWS

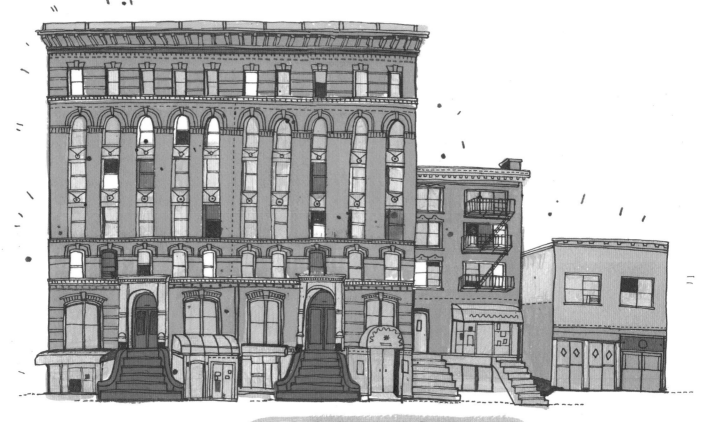

142 WEST 4TH ST

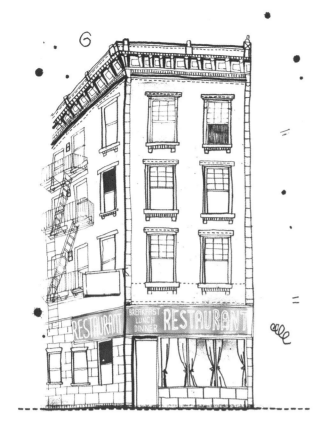

385 6th AVENUE

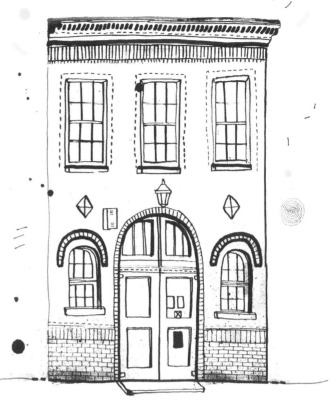

WASHINGTON MEWS

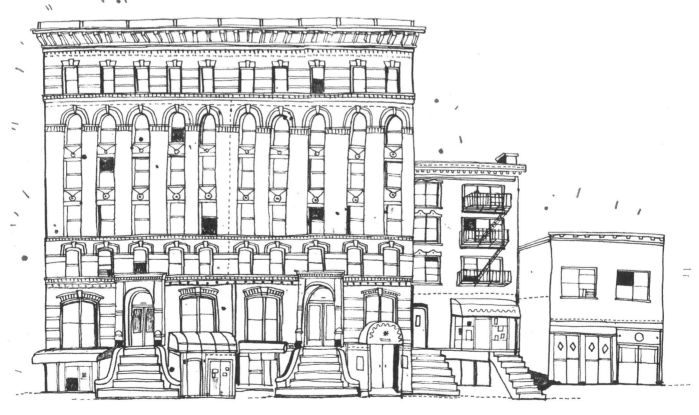

142 WEST 4TH ST

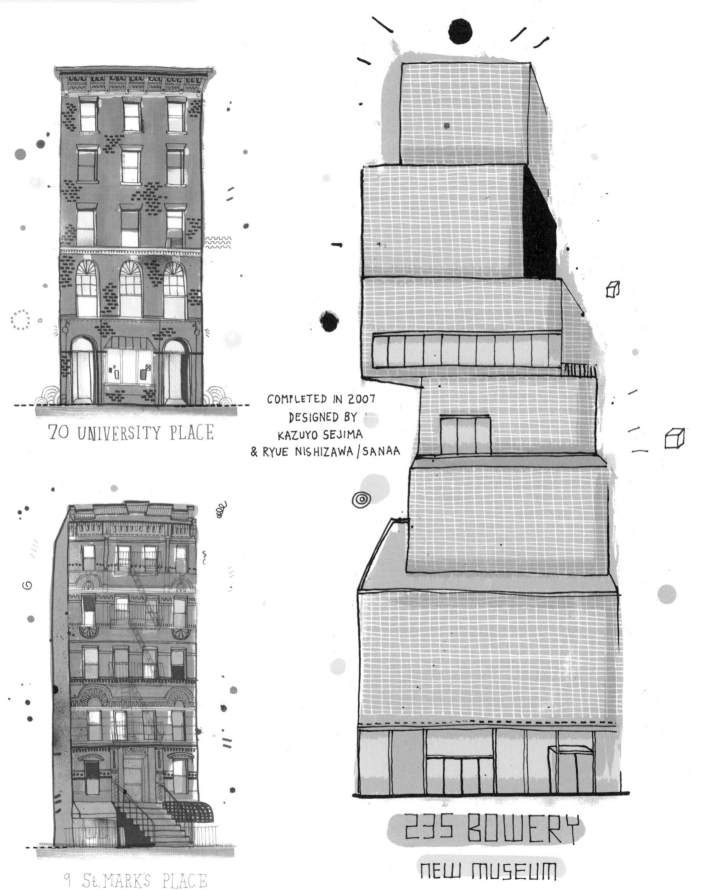

70 UNIVERSITY PLACE

9 St.MARK'S PLACE

COMPLETED IN 2007
DESIGNED BY
KAZUYO SEJIMA
& RYUE NISHIZAWA / SANAA

235 BOWERY

NEW MUSEUM

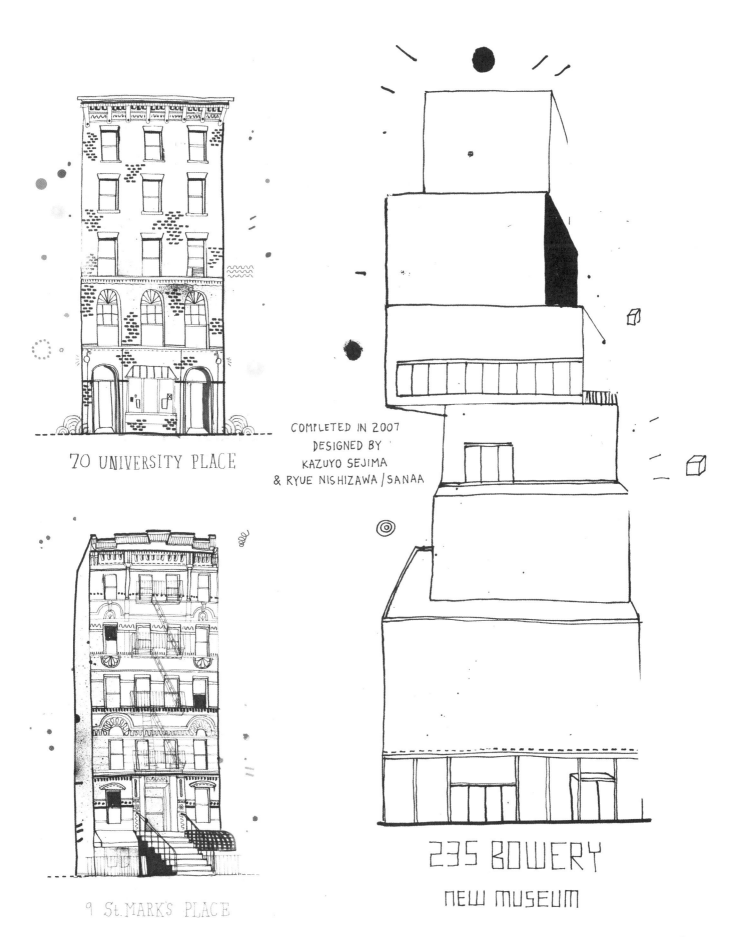

70 UNIVERSITY PLACE

9 St. MARK'S PLACE

COMPLETED IN 2007
DESIGNED BY
KAZUYO SEJIMA
& RYUE NISHIZAWA / SANAA

235 BOWERY

NEW MUSEUM

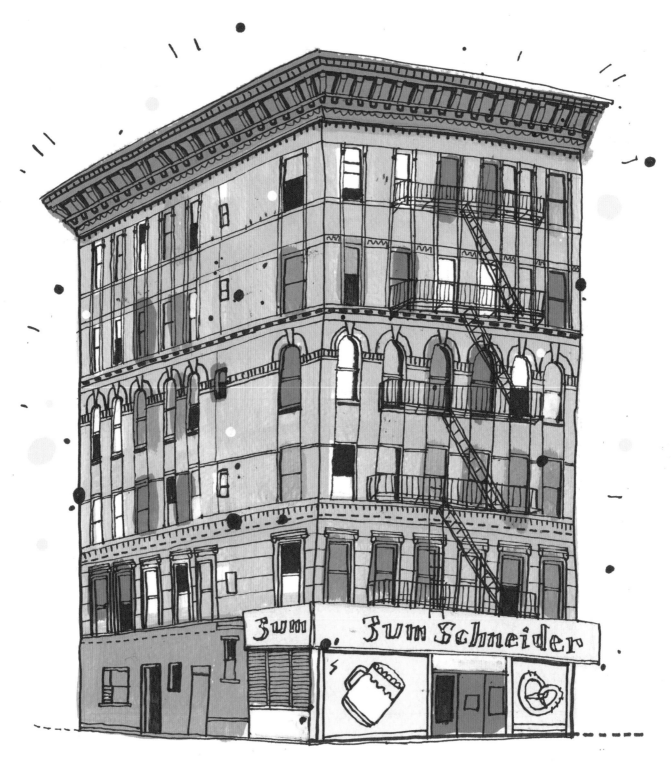

107 AVENUE C

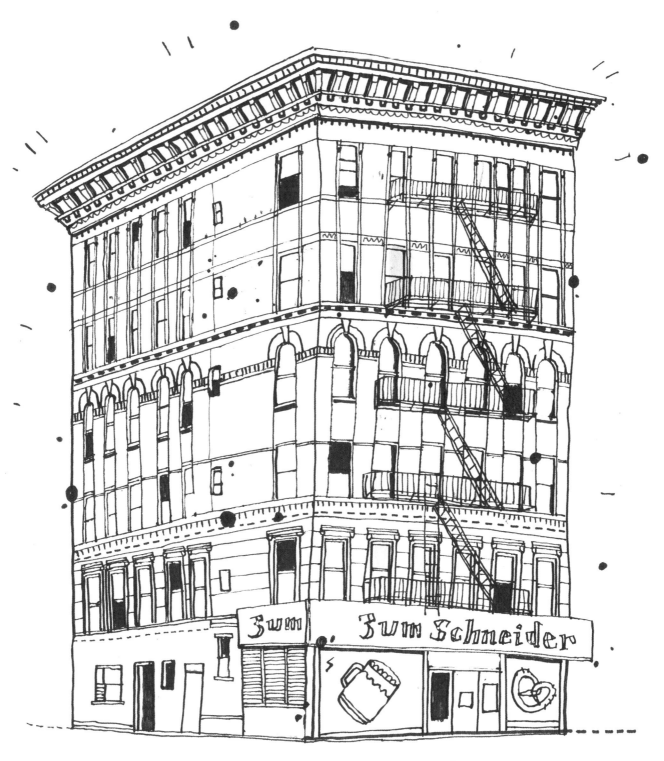

107 AVENUE C

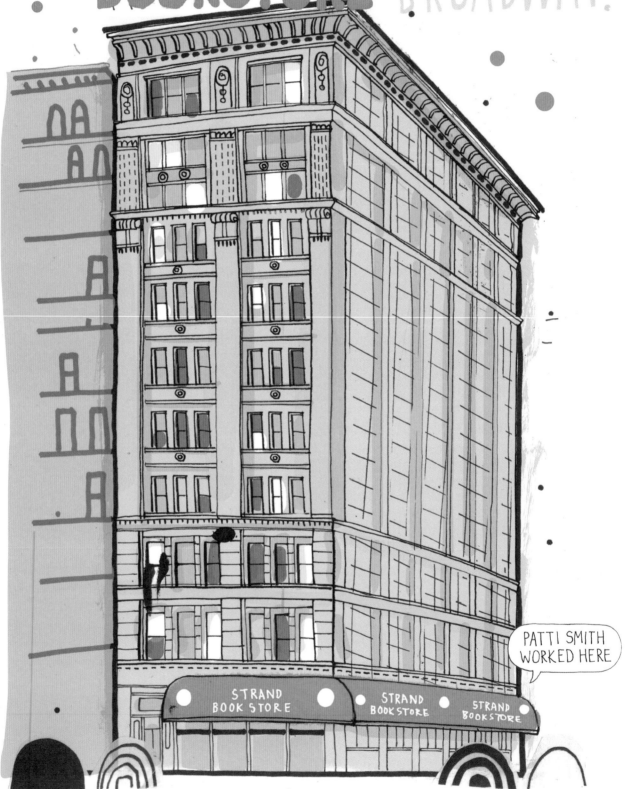

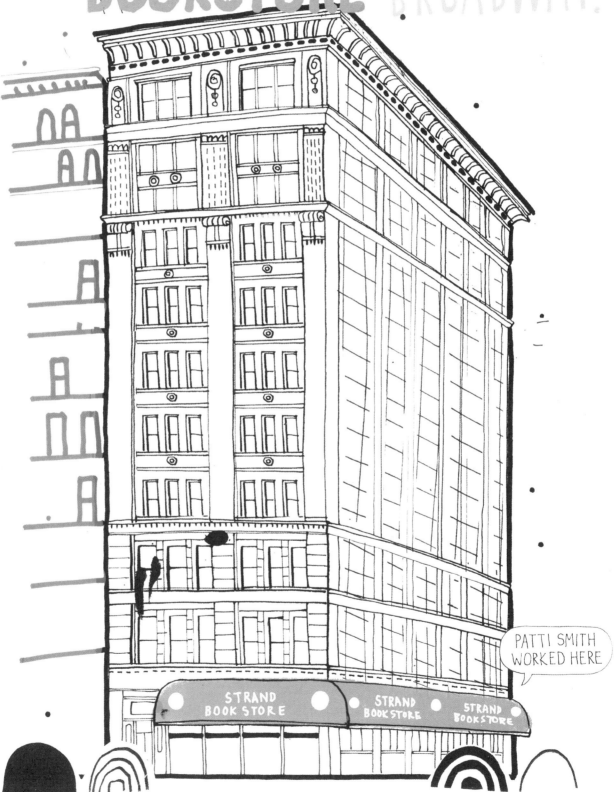

121 EAST 23RD STREET

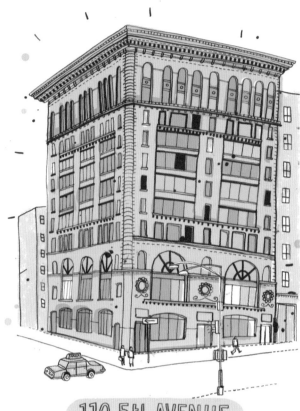

110 5th AVENUE

FLATIRON DISTRICT

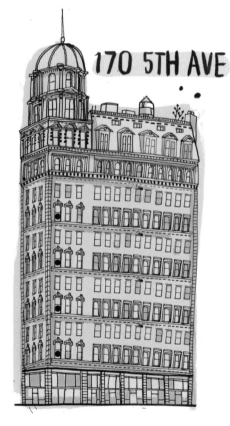

170 5TH AVE

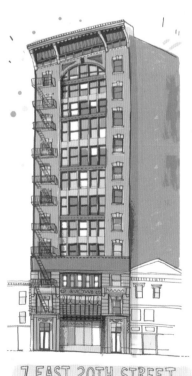

7 EAST 20TH STREET

301 EAST 22ND STREET

121 EAST 23RD STREET

110 5th AVENUE

170 5TH AVE

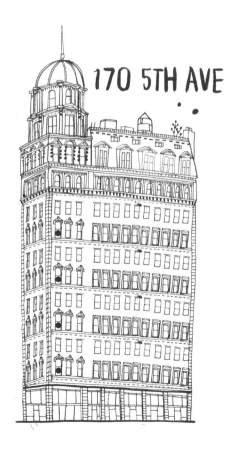

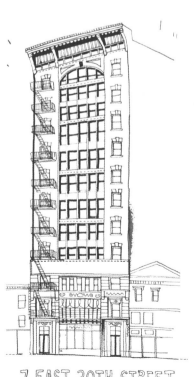

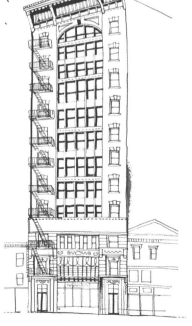

7 EAST 20TH STREET

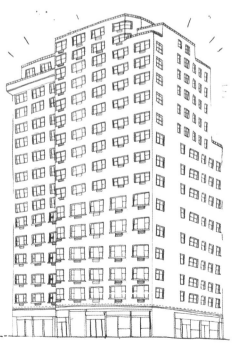

301 EAST 22ND STREET

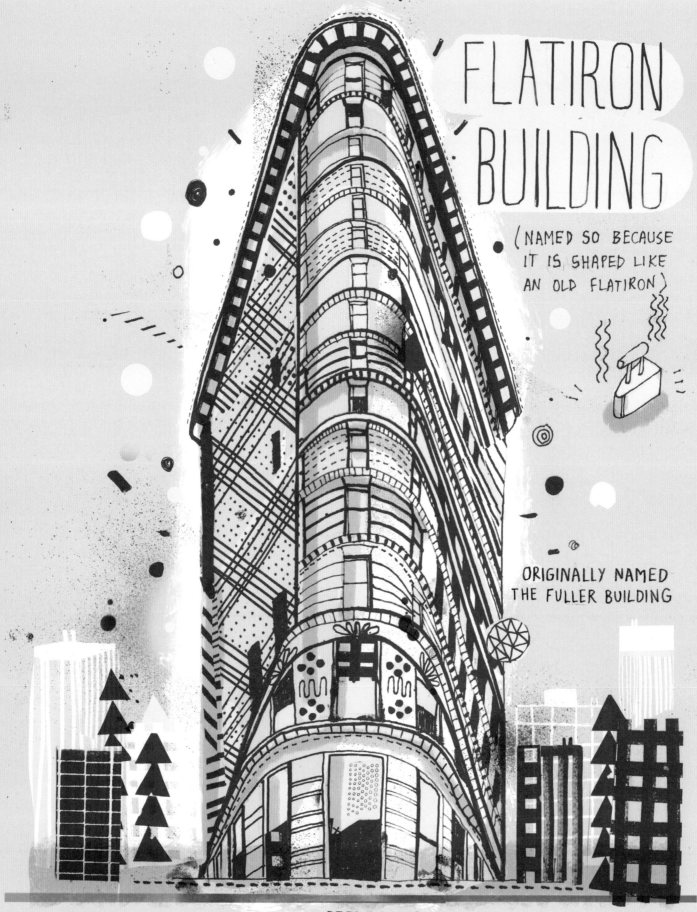

FLATIRON
BUILDING

(NAMED SO BECAUSE
IT IS SHAPED LIKE
AN OLD FLATIRON)

ORIGINALLY NAMED
THE FULLER BUILDING

COMPLETED IN 1902
DESIGNED BY DANIEL H. BURNHAM

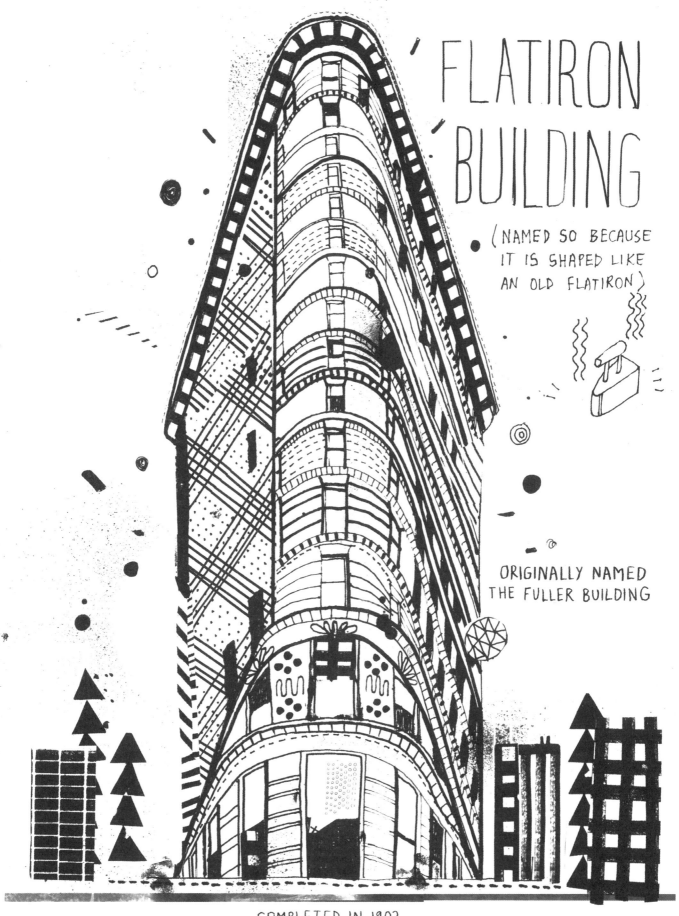

FLATIRON BUILDING

(NAMED SO BECAUSE IT IS SHAPED LIKE AN OLD FLATIRON)

ORIGINALLY NAMED THE FULLER BUILDING

COMPLETED IN 1902
DESIGNED BY DANIEL H. BURNHAM

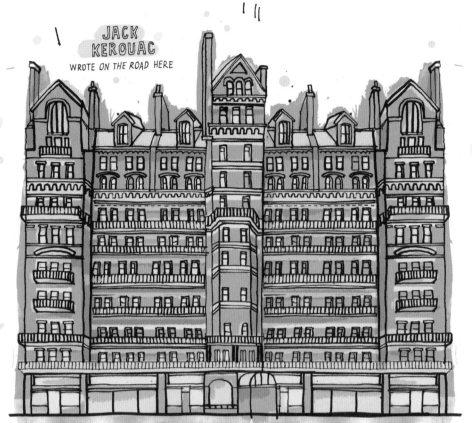

JACK KEROUAC
WROTE *ON THE ROAD* HERE

WAS HOME TO:
BOB DYLAN, CHARLES BUKOWSKI,
JANIS JOPLIN, LEONARD COHEN,
IGGY POP, DYLAN THOMAS,
ANDY WARHOL, ALLEN GINSBERG,
GORE VIDAL, STANLEY KUBRICK,
JANE FONDA, JIMI HENDRIX,
MADONNA, FRIDA KAHLO ETC ETC.

HOTEL CHELSEA
222 WEST 23RD ST

CHELSEA

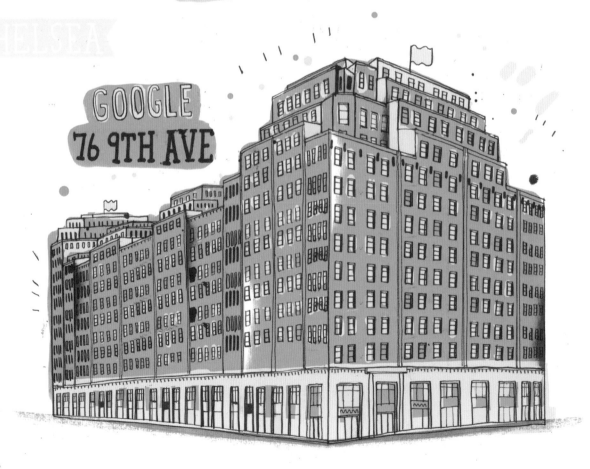

GOOGLE
76 9TH AVE

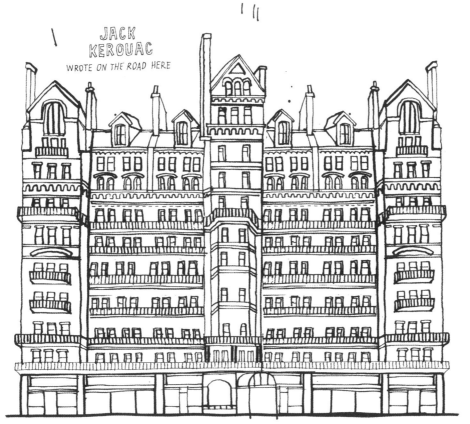

JACK KEROUAC WROTE ON THE ROAD HERE

WAS HOME TO:

BOB DYLAN, CHARLES BUKOWSKI, JANIS JOPLIN, LEONARD COHEN, IGGY POP, DYLAN THOMAS, ANDY WARHOL, ALLEN GINSBERG, GORE VIDAL, STANLEY KUBRICK, JANE FONDA, JIMI HENDRIX, MADONNA, FRIDA KAHLO ETC ETC.

HOTEL CHELSEA
222 WEST 23RD ST

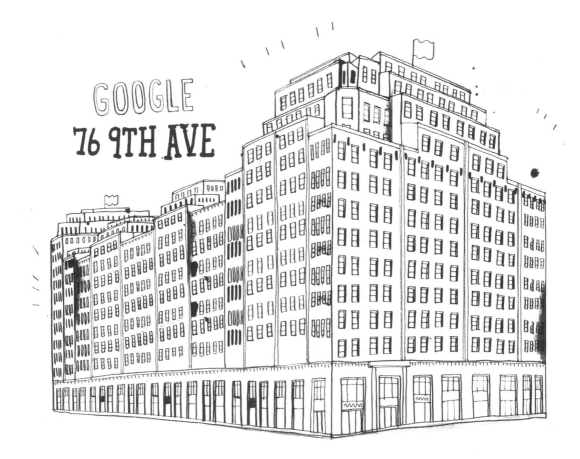

GOOGLE
76 9TH AVE

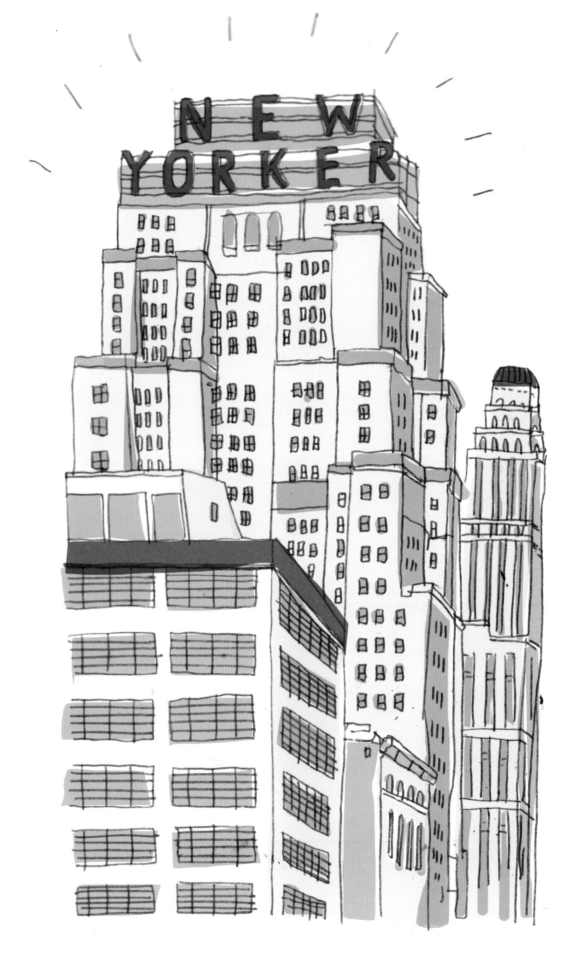

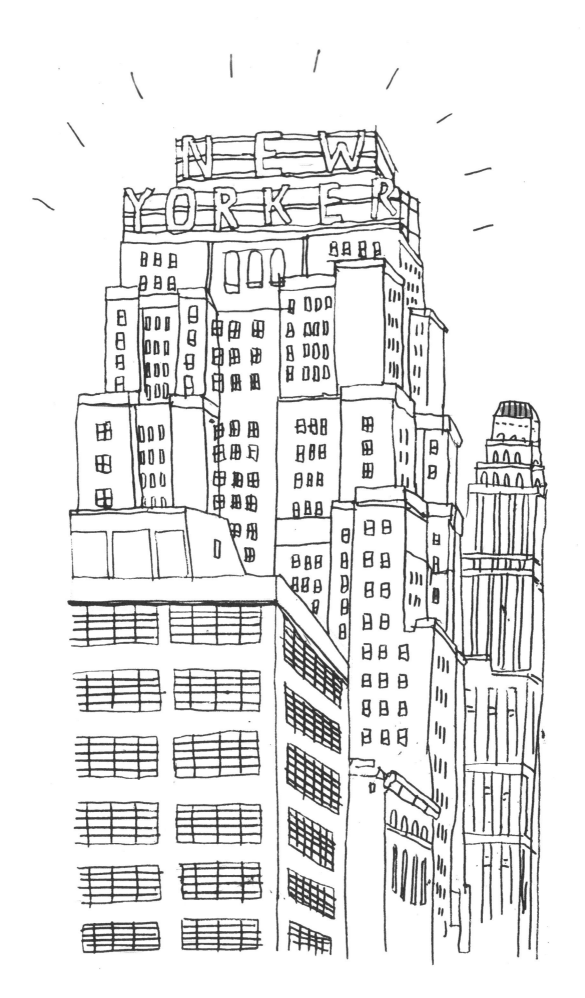

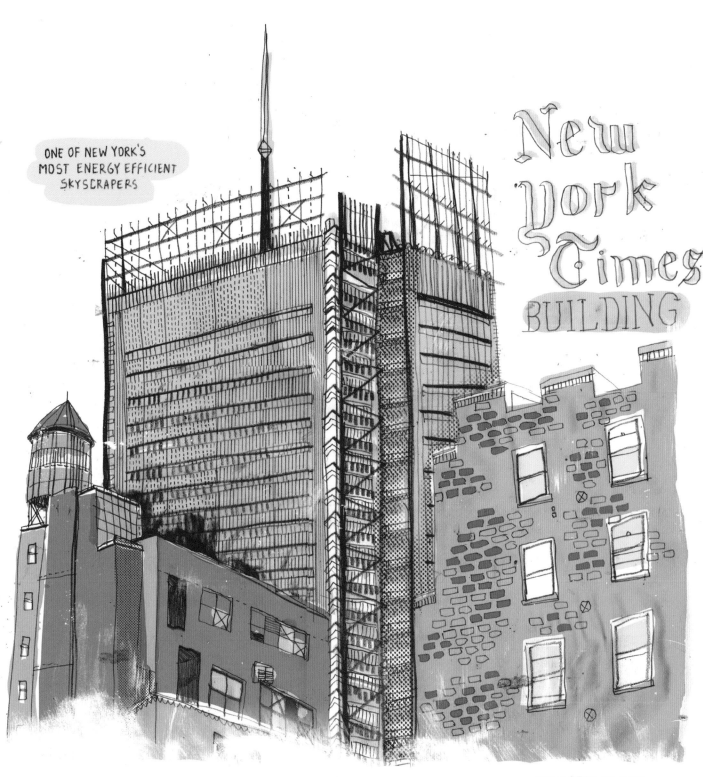

ONE OF NEW YORK'S MOST ENERGY EFFICIENT SKYSCRAPERS

New York Times BUILDING

COMPLETED IN 2007
DESIGNED BY RENZO PIANO

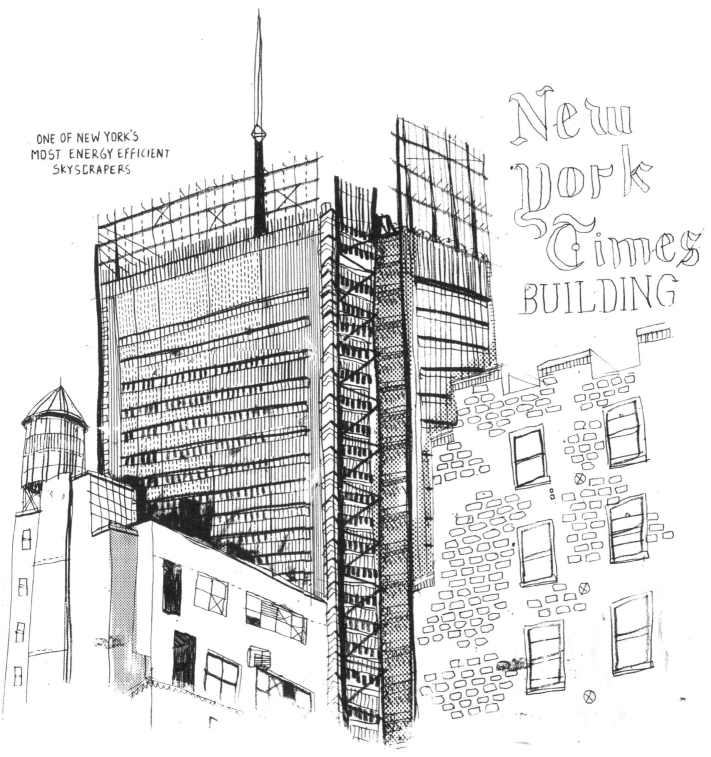

ONE OF NEW YORK'S
MOST ENERGY EFFICIENT
SKYSCRAPERS

New York Times BUILDING

COMPLETED IN 2007
DESIGNED BY RENZO PIANO

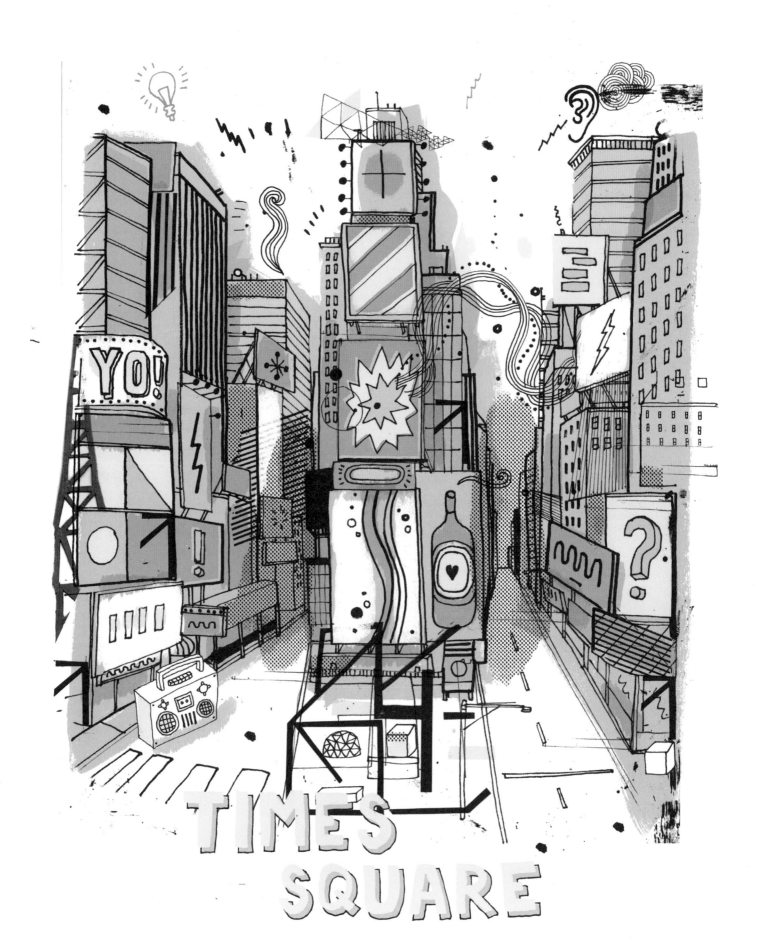

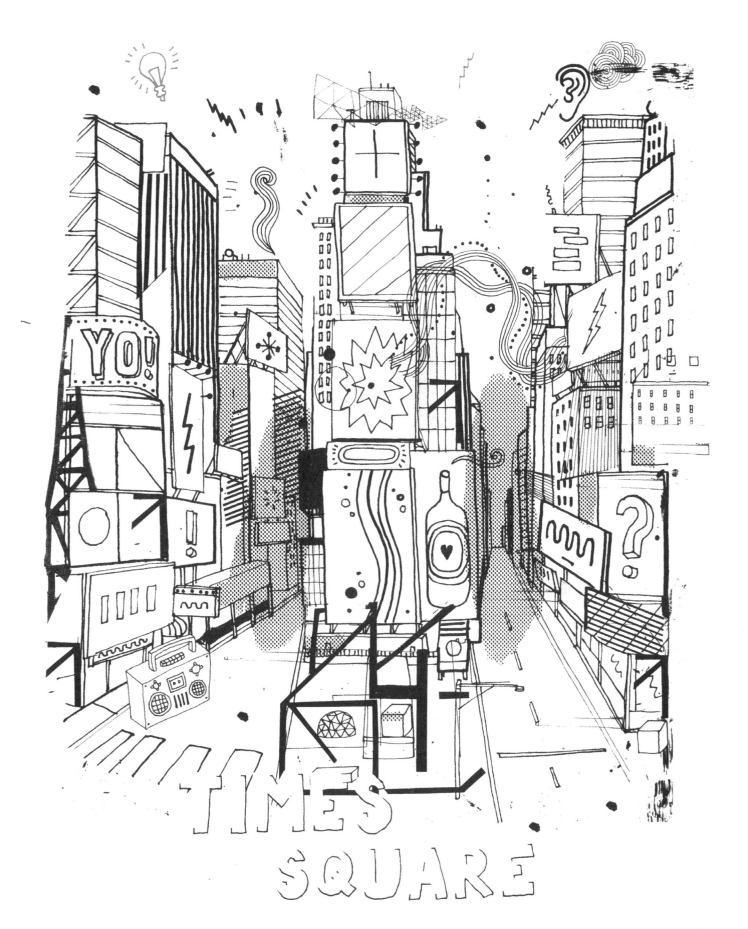

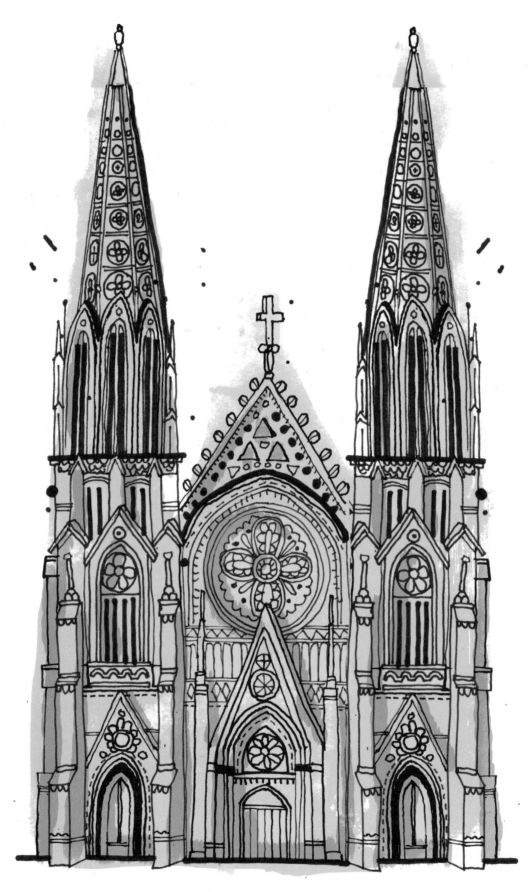

ST PATRICK'S CATHEDRAL

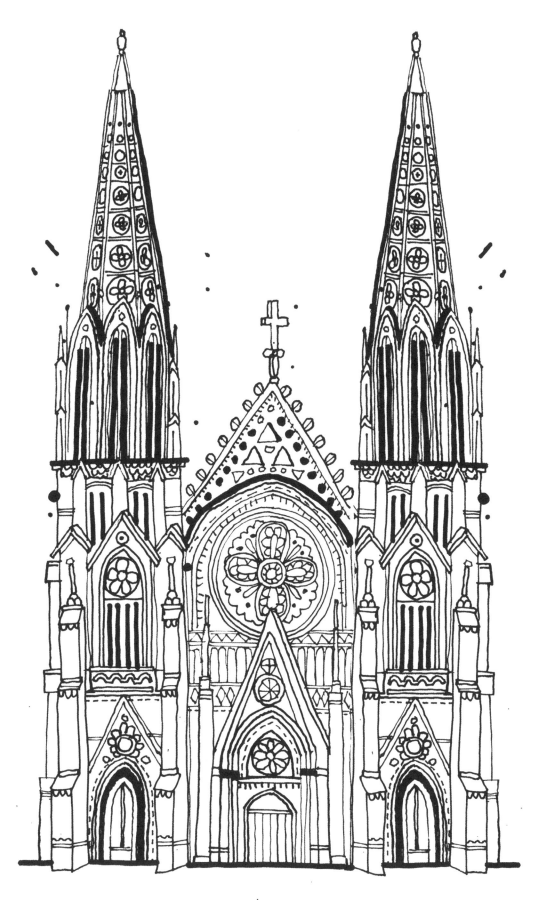

ST PATRICK'S CATHEDRAL

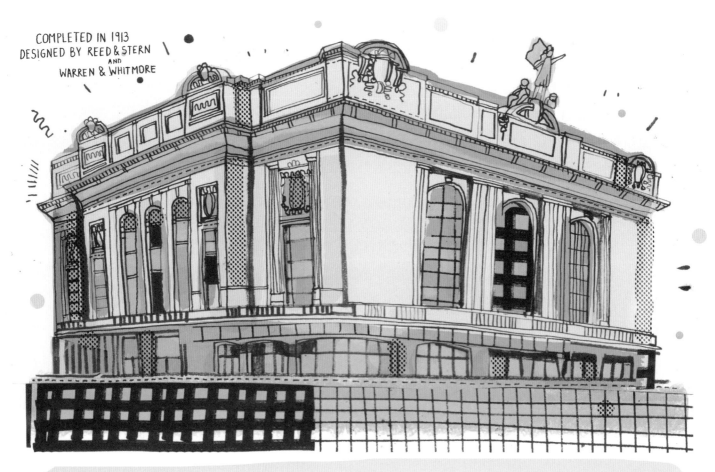

COMPLETED IN 1913
DESIGNED BY REED & STERN
AND
WARREN & WHITMORE

GRAND CENTRAL TERMINAL

AKA "GRAND CENTRAL STATION"

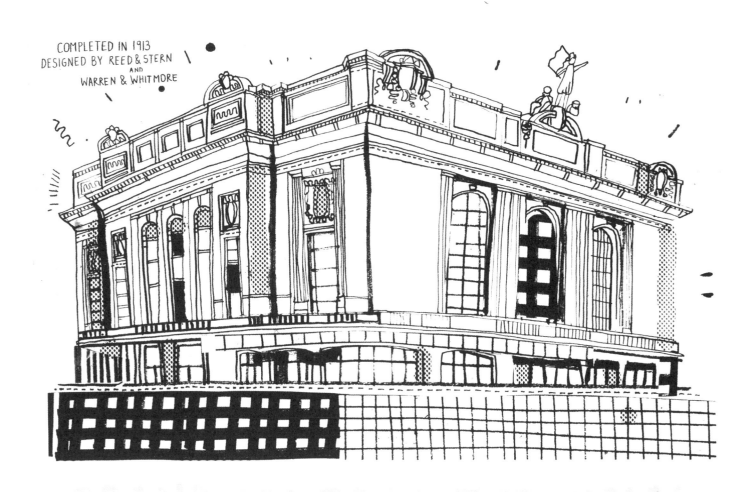

COMPLETED IN 1913
DESIGNED BY REED & STERN
AND
WARREN & WHITMORE

AKA "GRAND CENTRAL STATION"

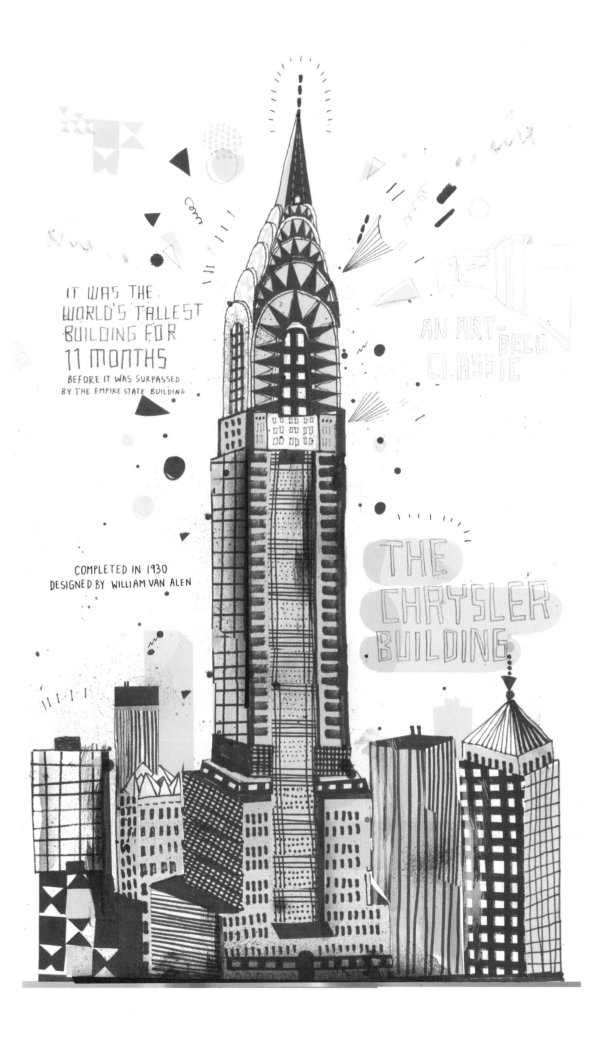

IT WAS THE
WORLD'S TALLEST
BUILDING FOR
11 MONTHS
BEFORE IT WAS SURPASSED
BY THE EMPIRE STATE BUILDING

AN ART-DECO CLASSIC

COMPLETED IN 1930
DESIGNED BY WILLIAM VAN ALEN

THE CHRYSLER BUILDING

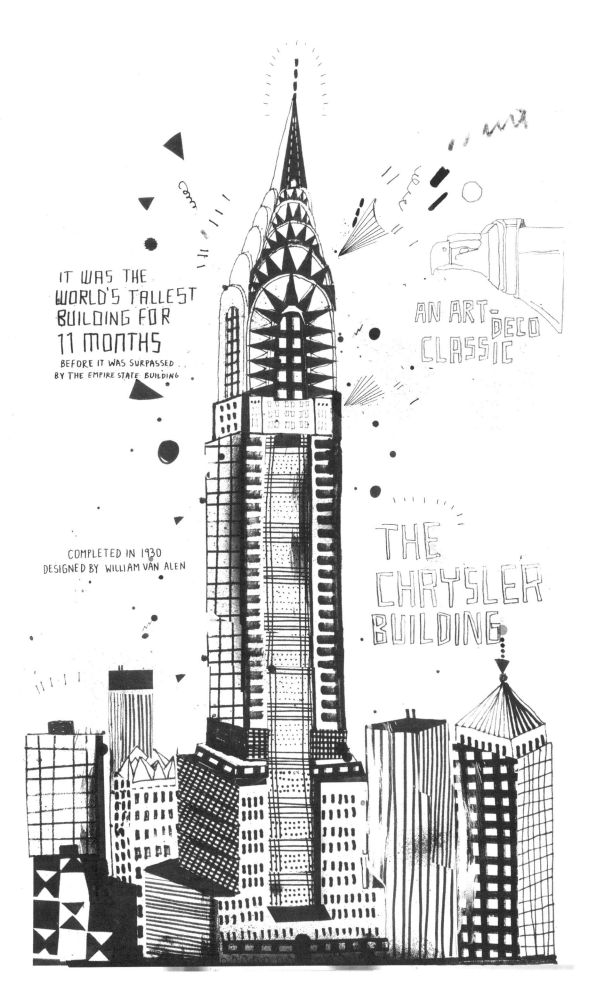

IT WAS THE WORLD'S TALLEST BUILDING FOR 11 MONTHS
BEFORE IT WAS SURPASSED BY THE EMPIRE STATE BUILDING

AN ART-DECO CLASSIC

COMPLETED IN 1930
DESIGNED BY WILLIAM VAN ALEN

THE CHRYSLER BUILDING

211 EAST 53RD STREET

730 5TH AVENUE

61 WEST 62ND STREET

211 EAST 53RD STREET

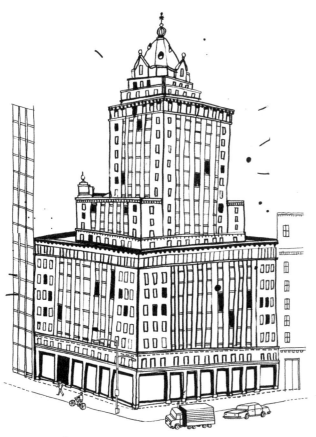

730 5TH AVENUE

61 WEST 62ND STREET

ROCKEFELLER CENTER

HOME TO
30 ROCKEFELLER PLAZA
(30 ROCK)
& RADIO CITY MUSIC HALL

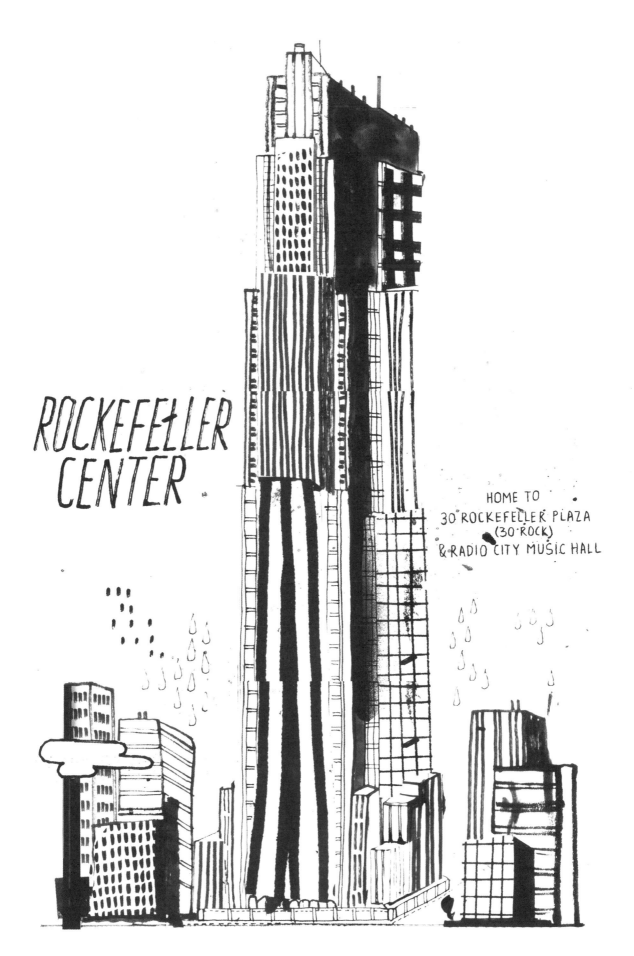

ROCKEFELLER
CENTER

HOME TO
30 ROCKEFELLER PLAZA
(30 ROCK)
& RADIO CITY MUSIC HALL

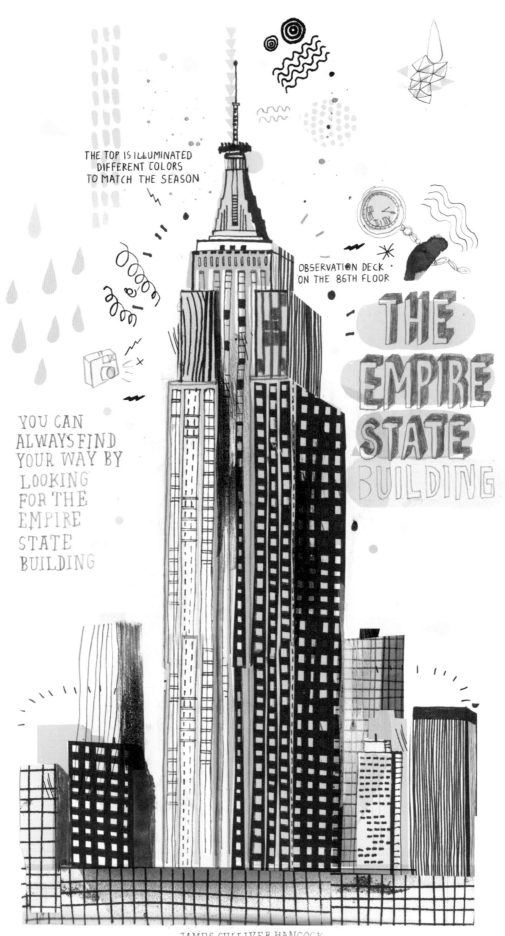

THE TOP IS ILLUMINATED DIFFERENT COLORS TO MATCH THE SEASON

OBSERVATION DECK ON THE 86TH FLOOR

THE EMPIRE STATE BUILDING

YOU CAN ALWAYS FIND YOUR WAY BY LOOKING FOR THE EMPIRE STATE BUILDING

JAMES GULLIVER HANCOCK

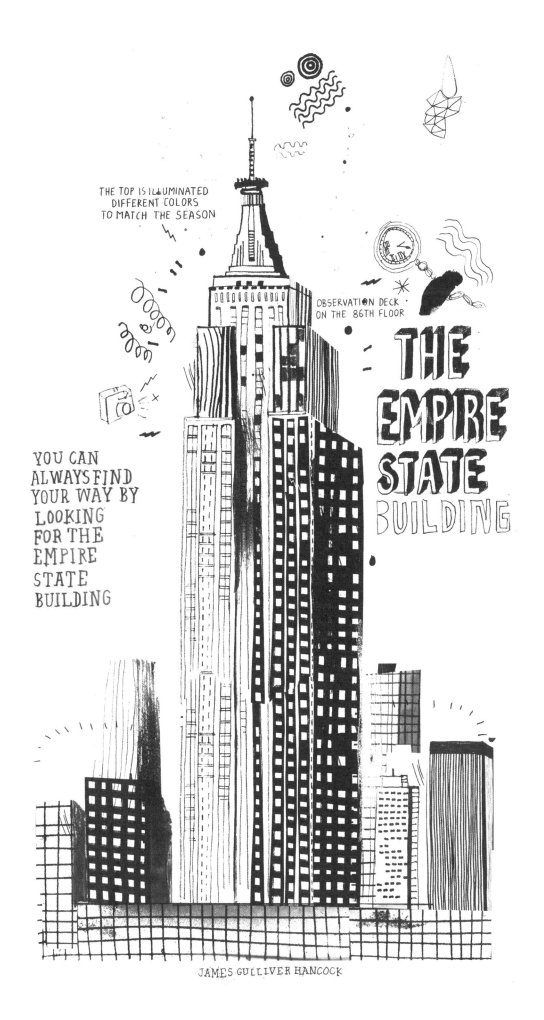

THE TOP IS ILLUMINATED
DIFFERENT COLORS
TO MATCH THE SEASON

OBSERVATION DECK
ON THE 86TH FLOOR

THE
EMPIRE
STATE
BUILDING

YOU CAN
ALWAYS FIND
YOUR WAY BY
LOOKING
FOR THE
EMPIRE
STATE
BUILDING

JAMES GULLIVER HANCOCK

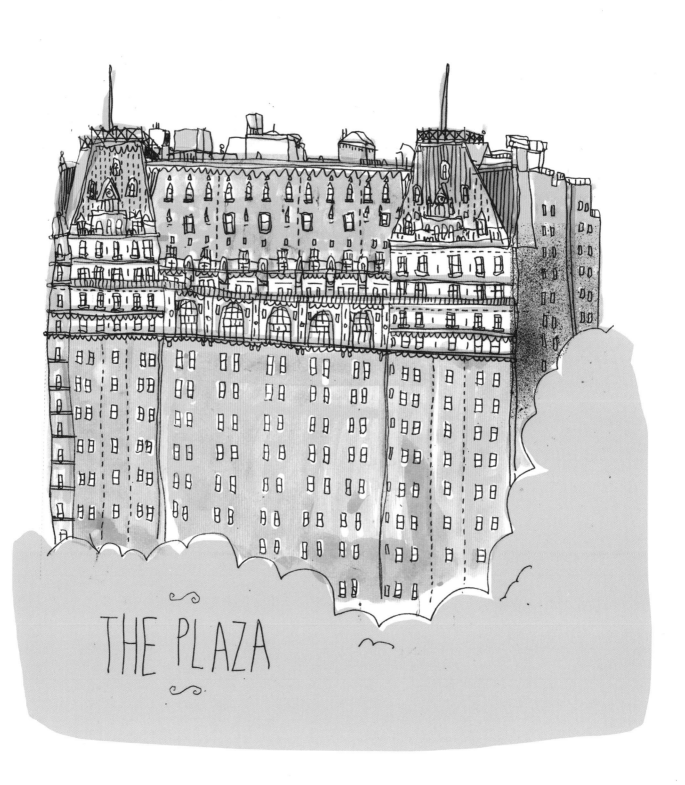

THE PLAZA

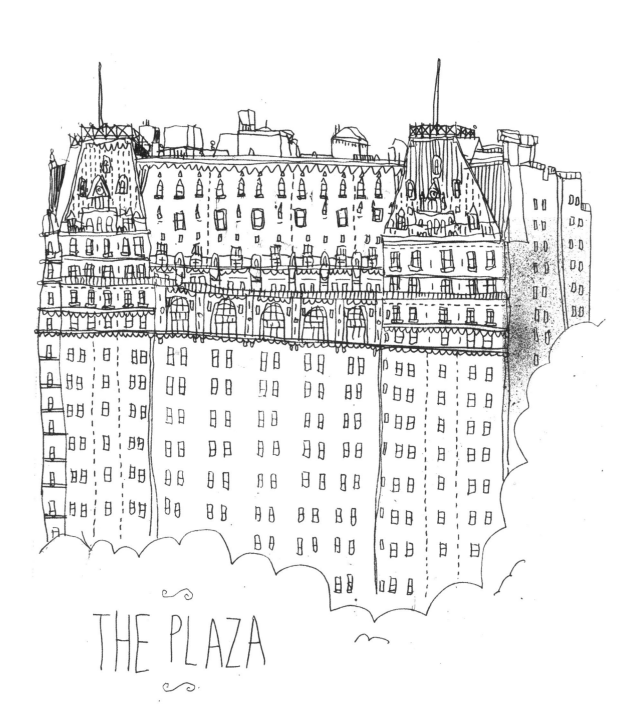

THE PLAZA

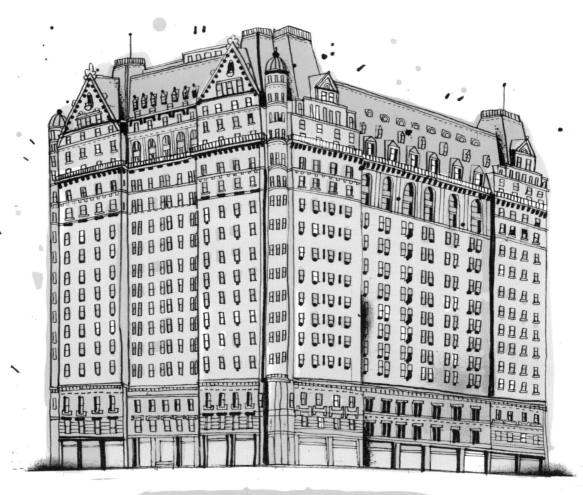

1 CENTRAL PARK SOUTH

25 SUTTON PLACE

767 5TH AVE

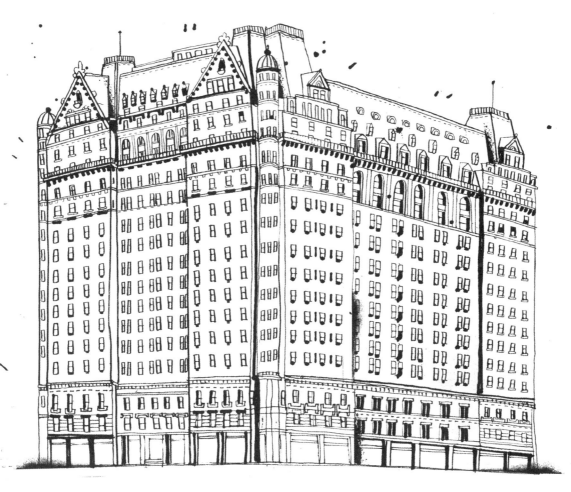

1 CENTRAL PARK SOUTH

25 SUTTON PLACE

767 5TH AVE

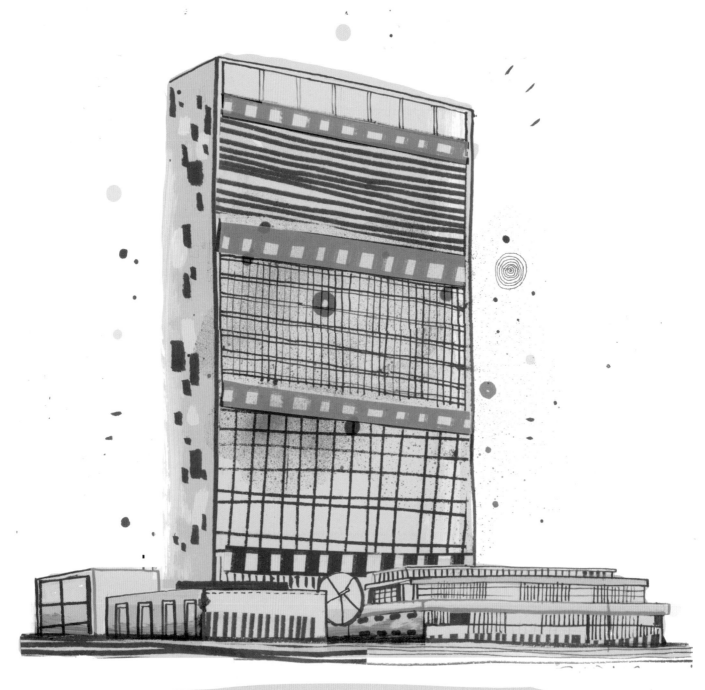

THE UNITED NATIONS

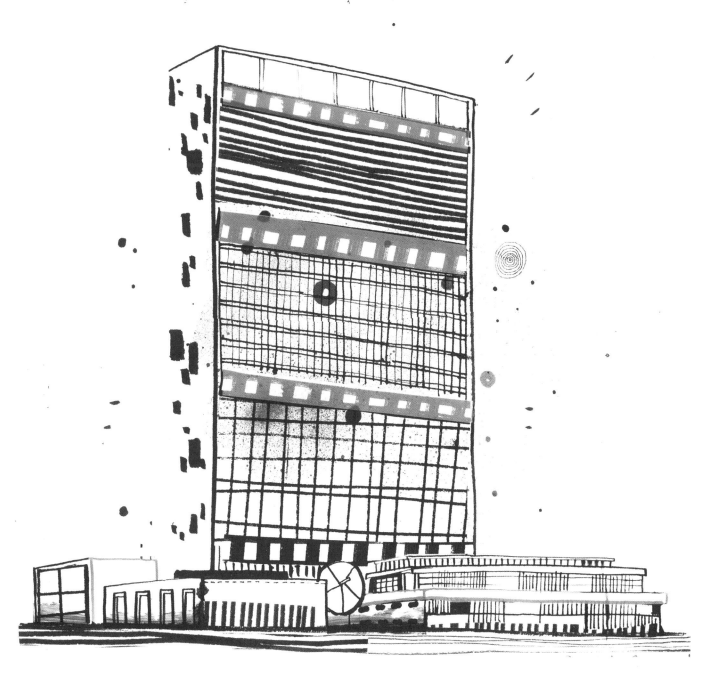

THE UNITED NATIONS

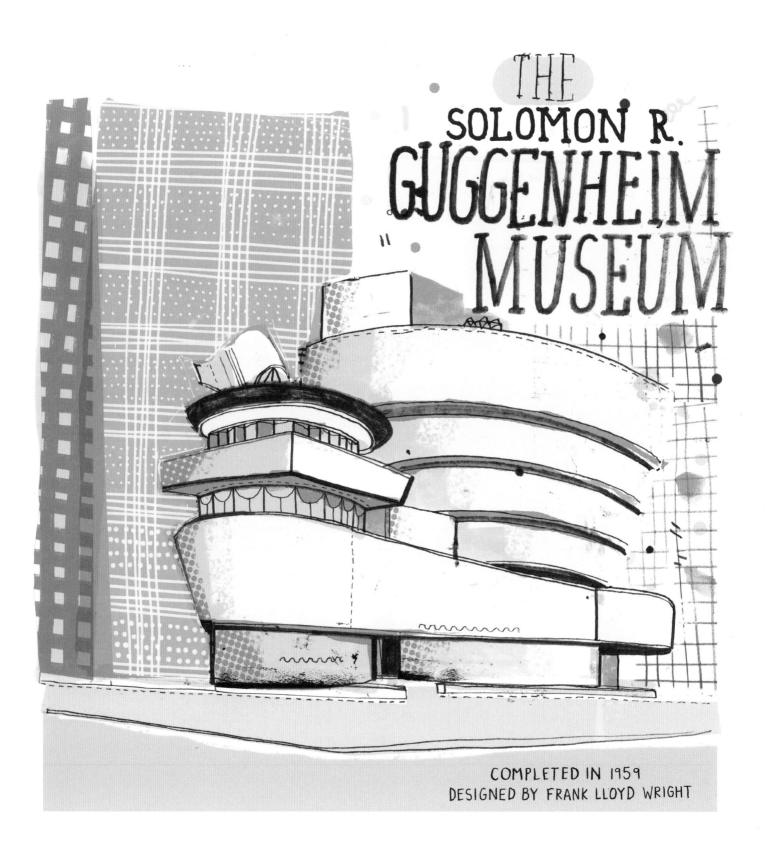

THE SOLOMON R. GUGGENHEIM MUSEUM

COMPLETED IN 1959
DESIGNED BY FRANK LLOYD WRIGHT

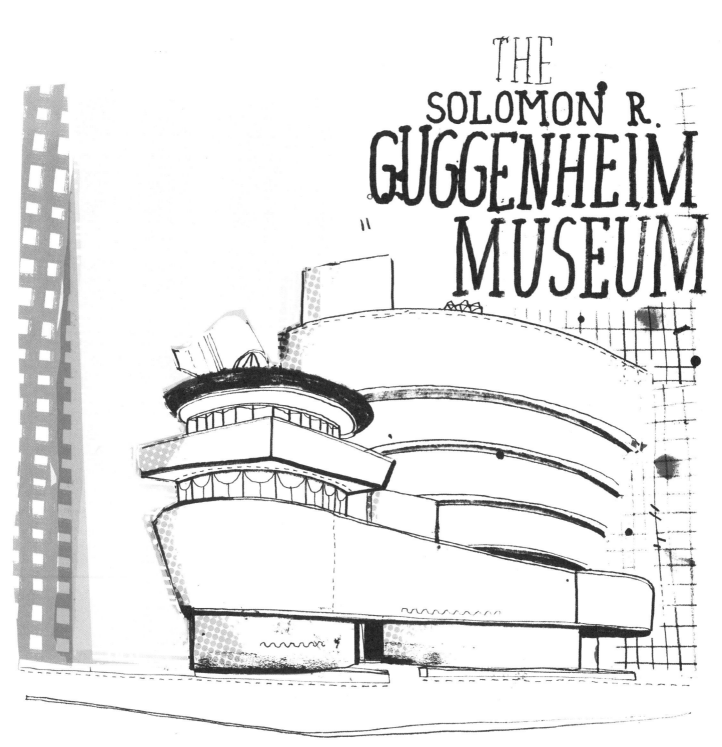

THE SOLOMON R. GUGGENHEIM MUSEUM

COMPLETED IN 1959
DESIGNED BY FRANK LLOYD WRIGHT

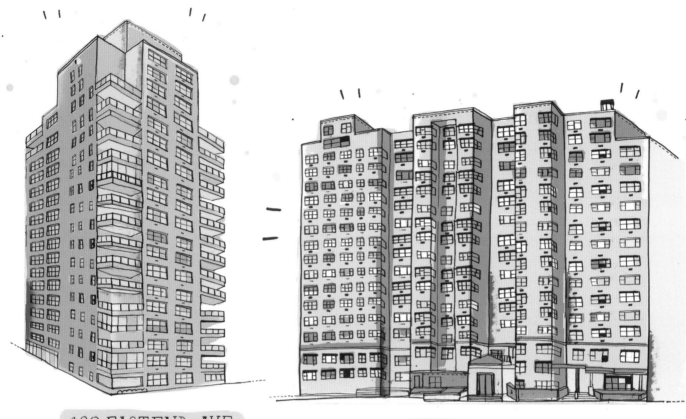

180 EASTEND AVE

8 EAST 83RD ST.

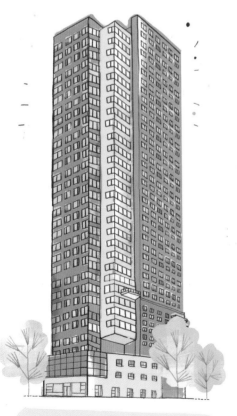

360 EAST 88TH ST.

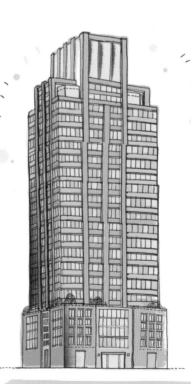

450 EAST 83RD ST.

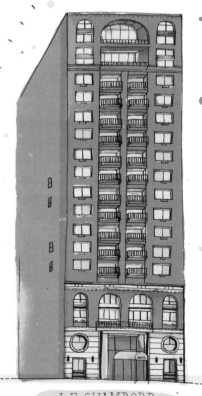

LE CHAMBORD
350 EAST 72ND ST

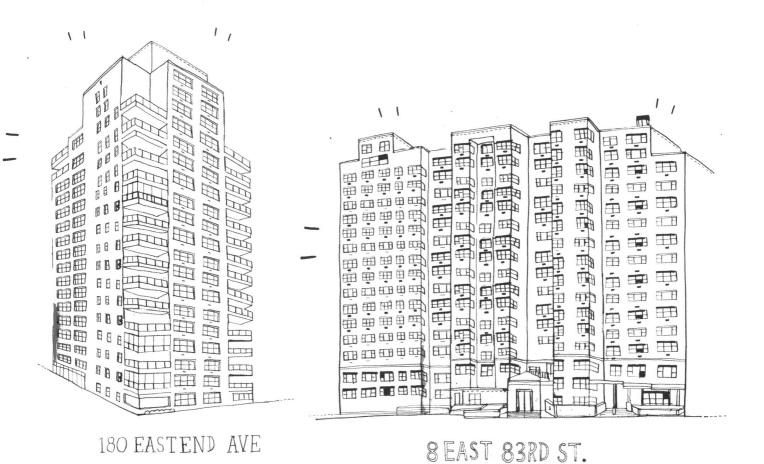

180 EASTEND AVE

8 EAST 83RD ST.

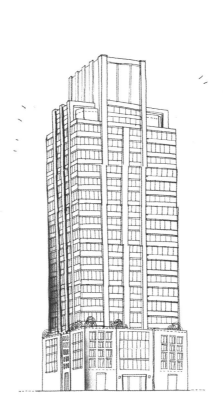

360 EAST 88TH ST.

450 EAST 83RD ST.

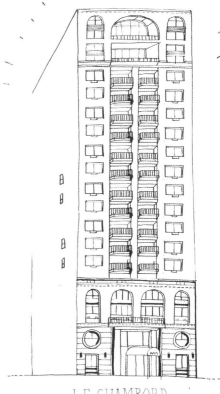

LE CHAMBORD
350 EAST 72ND ST

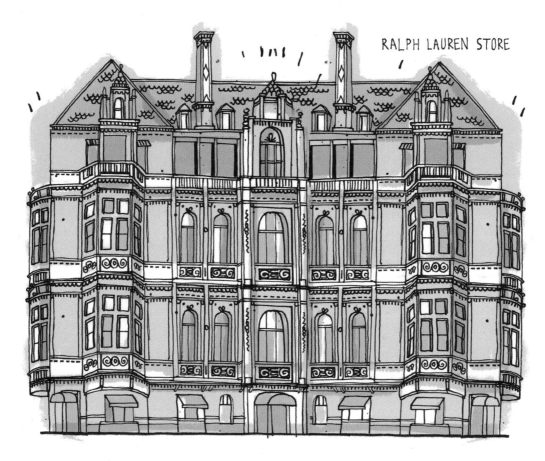

RALPH LAUREN STORE

888 MADISON AVE

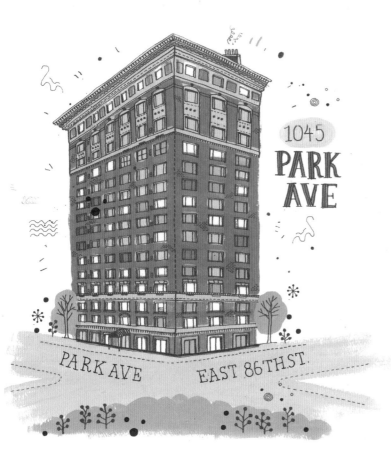

1045 PARK AVE

PARK AVE EAST 86TH ST.

301 EAST 75TH ST

RALPH LAUREN STORE

888 MADISON AVE

1045 PARK AVE

PARK AVE EAST 86TH ST

301 EAST 75TH ST

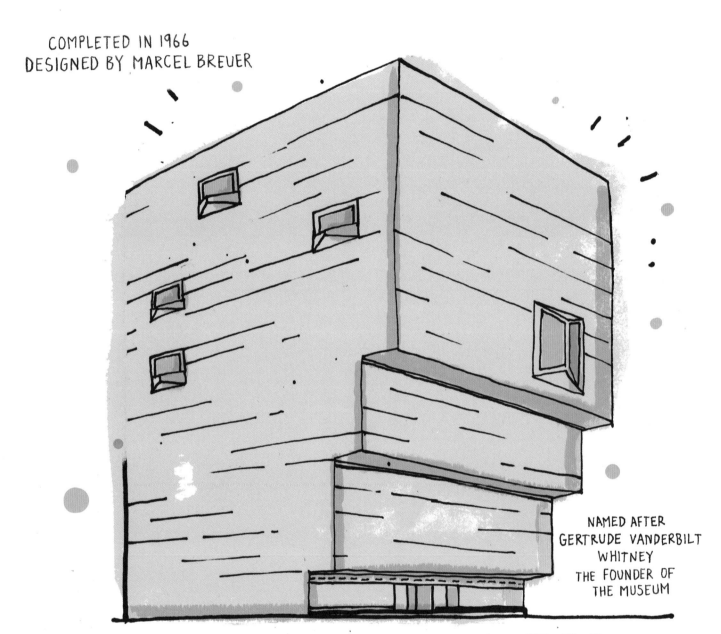

COMPLETED IN 1966
DESIGNED BY MARCEL BREUER

NAMED AFTER
GERTRUDE VANDERBILT
WHITNEY
THE FOUNDER OF
THE MUSEUM

THE WHITNEY

MUSEUM OF AMERICAN ART
945 MADISON AVE.

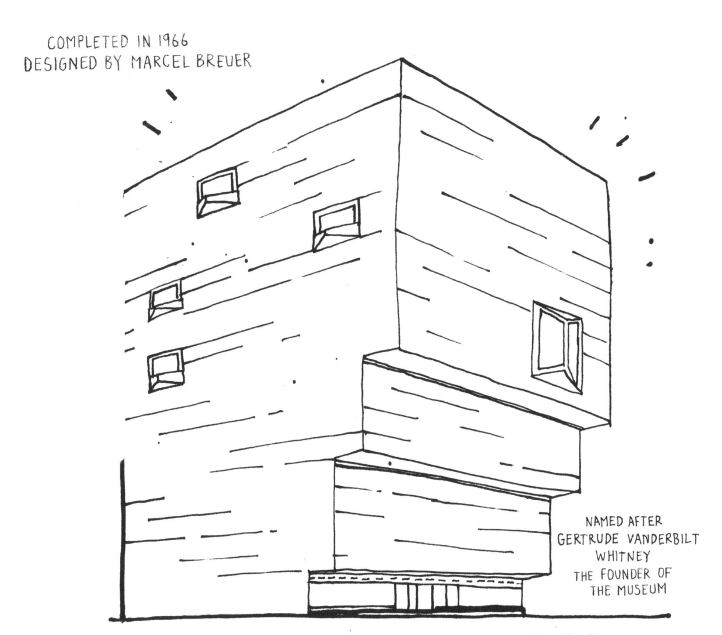

COMPLETED IN 1966
DESIGNED BY MARCEL BREUER

NAMED AFTER
GERTRUDE VANDERBILT
WHITNEY
THE FOUNDER OF
THE MUSEUM

THE WHITNEY
MUSEUM OF AMERICAN ART
945 MADISON AVE.

A TAXI TO
THE METROPOLITAN MUSEUM OF ART

THE LARGEST ART MUSEUM IN THE U.S.A.
CONTAINING OVER 2 MILLION WORKS

SINCE OPENING IN 1880
IT HAS GROWN TO 20 TIMES THE SIZE

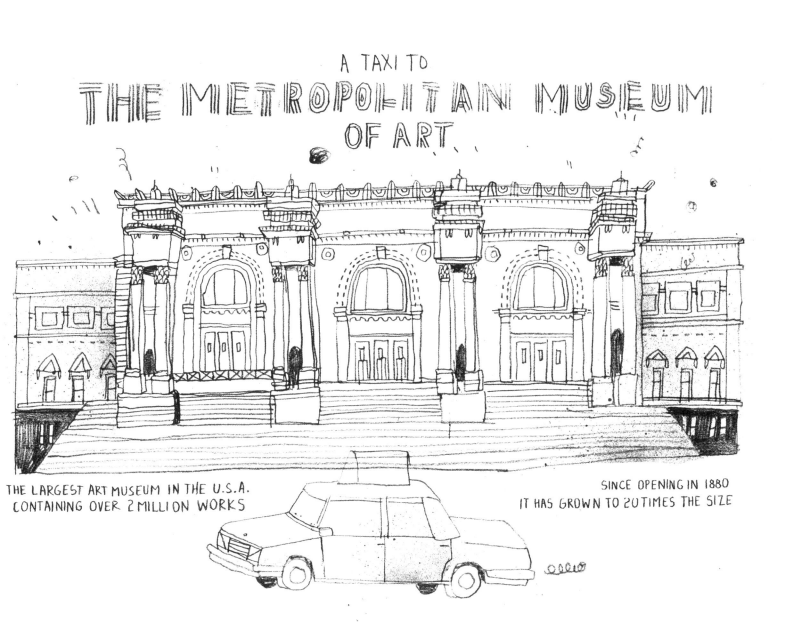

A TAXI TO
THE METROPOLITAN MUSEUM OF ART.

THE LARGEST ART MUSEUM IN THE U.S.A.
CONTAINING OVER 2 MILLION WORKS

SINCE OPENING IN 1880
IT HAS GROWN TO 20 TIMES THE SIZE

340 WEST 86TH ST.

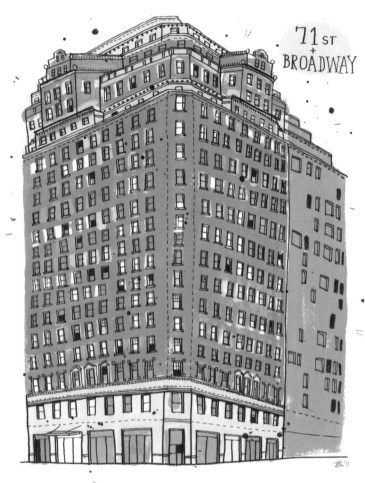

71ST + BROADWAY

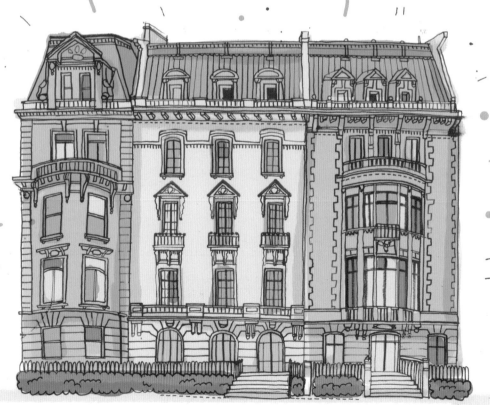

MARYMOUNT

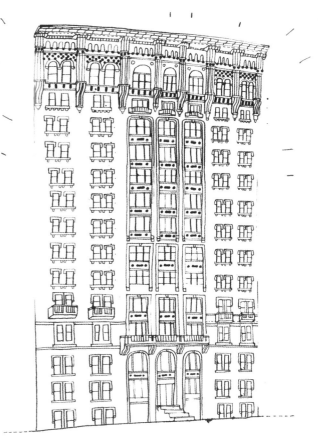

340 WEST 86TH ST.

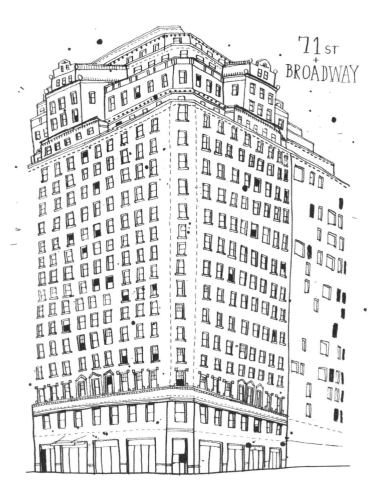

71ST
+
BROADWAY

MARYMOUNT

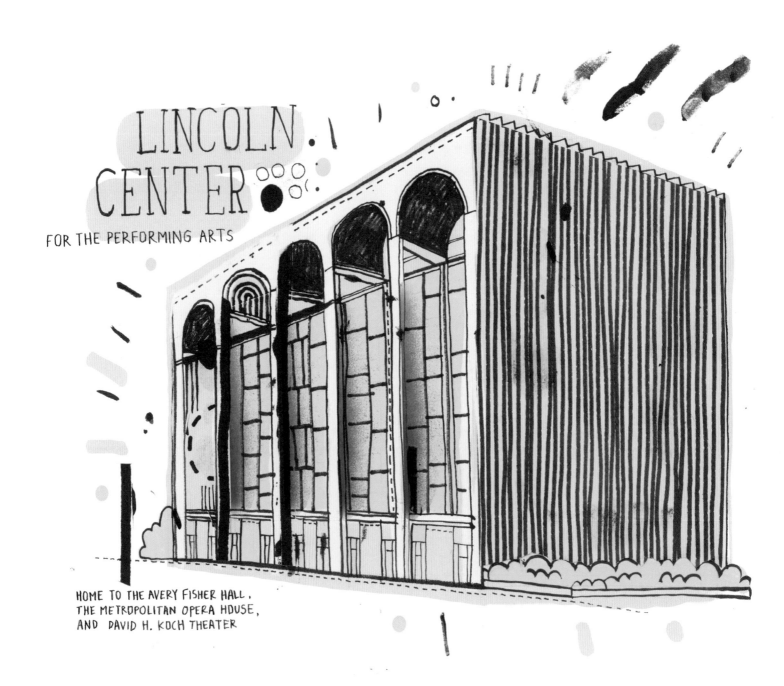

LINCOLN CENTER

FOR THE PERFORMING ARTS

HOME TO THE AVERY FISHER HALL,
THE METROPOLITAN OPERA HOUSE,
AND DAVID H. KOCH THEATER

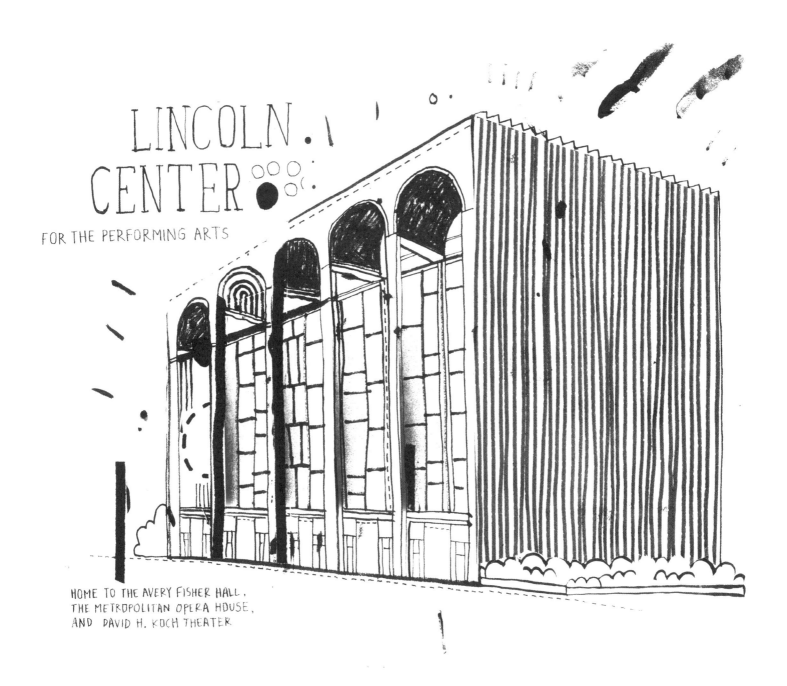

LINCOLN
CENTER
FOR THE PERFORMING ARTS

HOME TO THE AVERY FISHER HALL,
THE METROPOLITAN OPERA HOUSE,
AND DAVID H. KOCH THEATER

145-146 CENTRAL PARK WEST

150 COLUMBUS AVE.

320 CENTRAL PARK WEST

25 CENTRAL PARK WEST

150 COLUMBUS AVE.

320 CENTRAL PARK WEST

25 CENTRAL PARK WEST

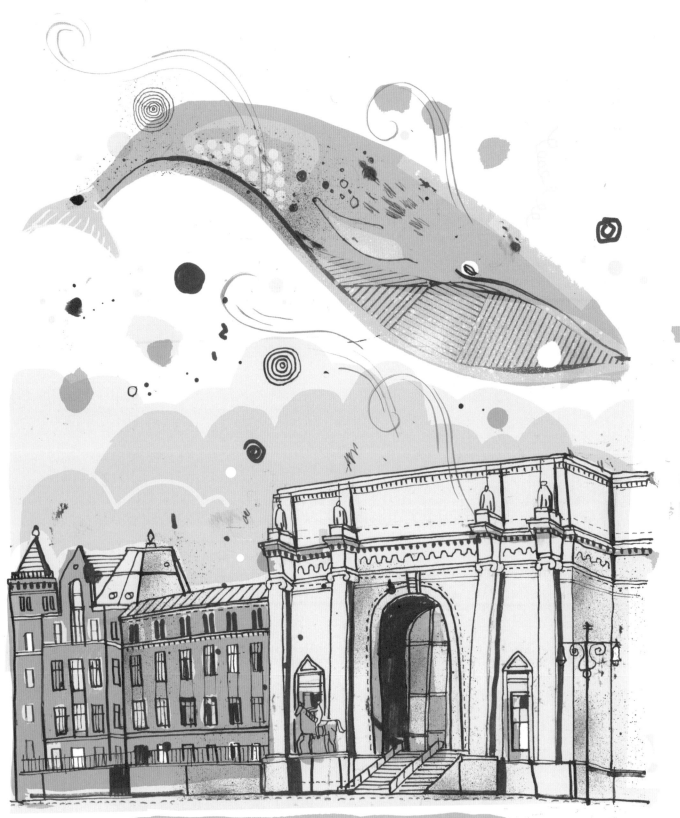

AMERICAN MUSEUM
OF NATURAL HISTORY

AMERICAN MUSEUM
OF NATURAL HISTORY

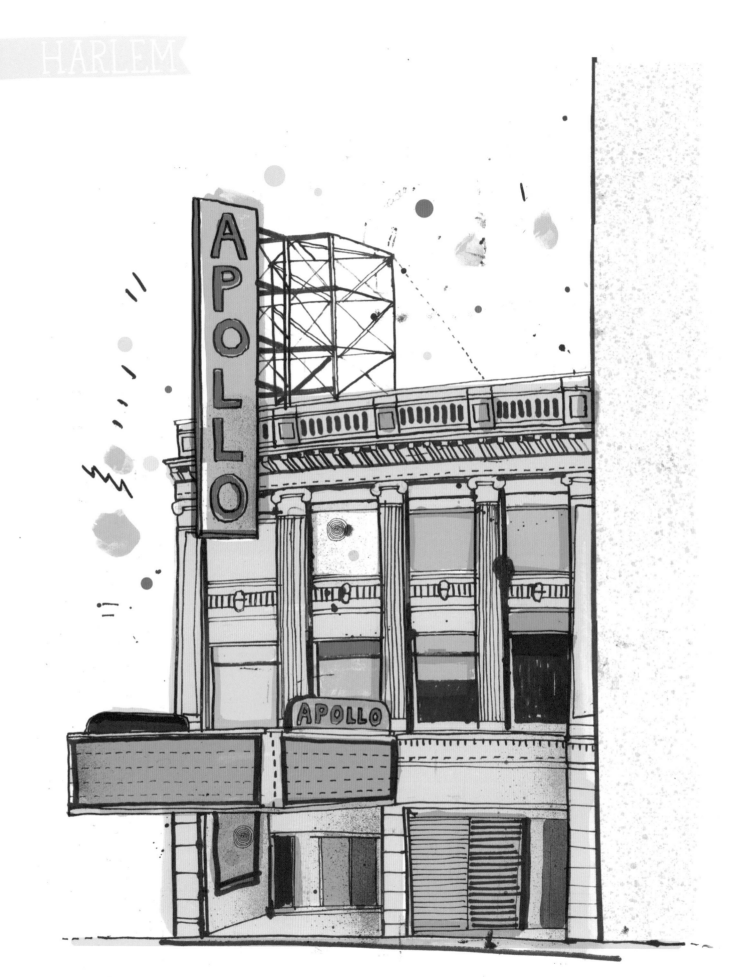

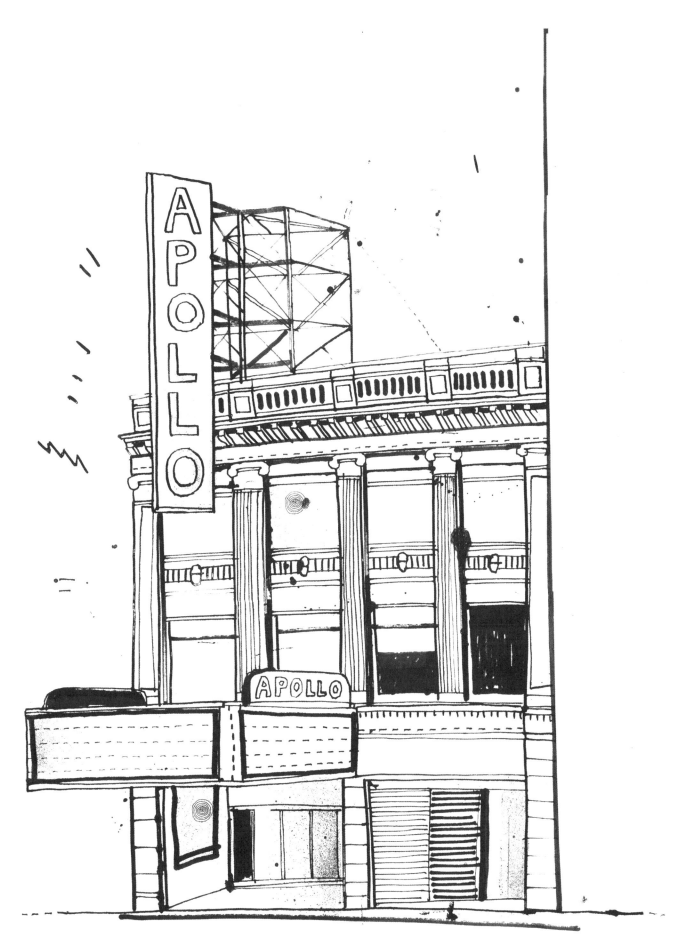

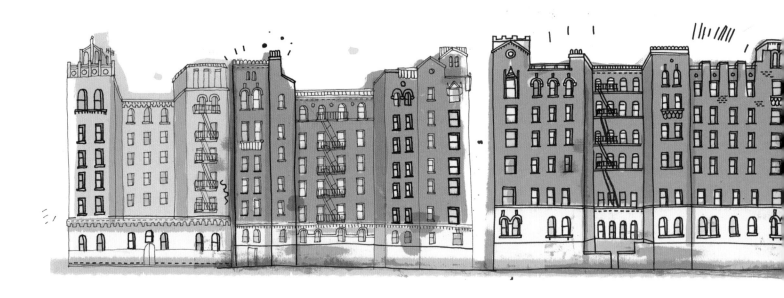

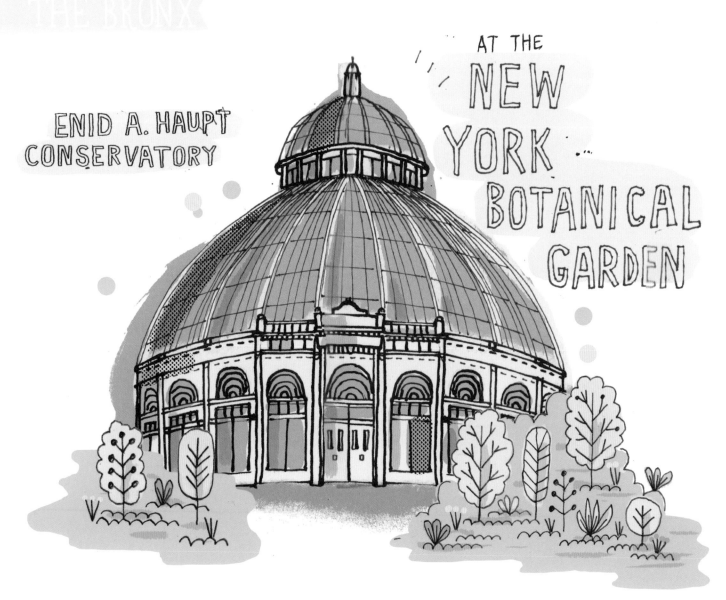

ENID A. HAUPT
CONSERVATORY

AT THE
NEW
YORK
BOTANICAL
GARDEN

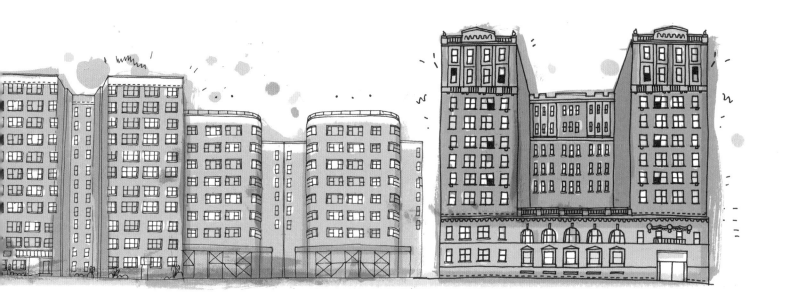

161-164 GRAND CONCOURSE

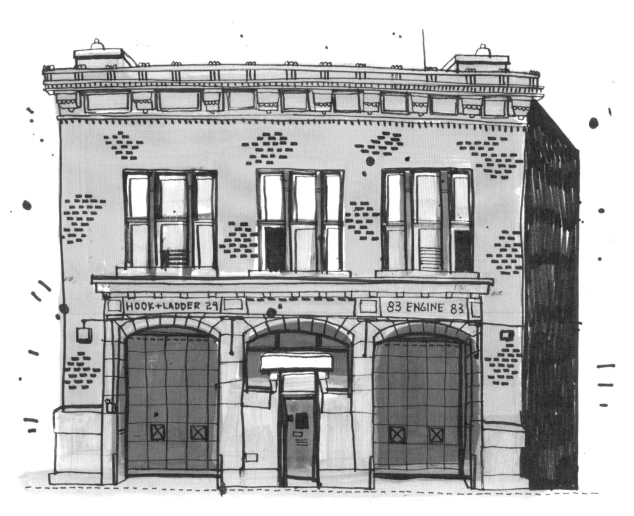

618 EAST 138TH ST.

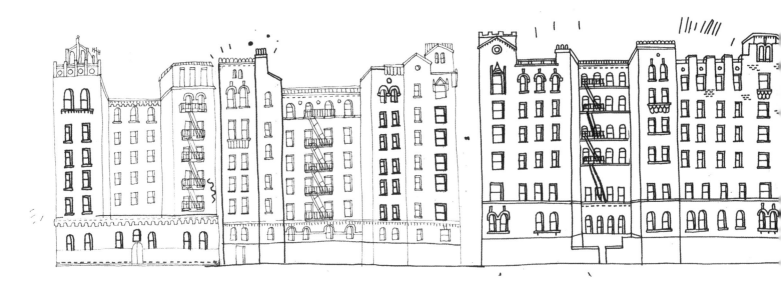

ENID A. HAUPT
CONSERVATORY

AT THE
NEW
YORK
BOTANICAL
GARDEN

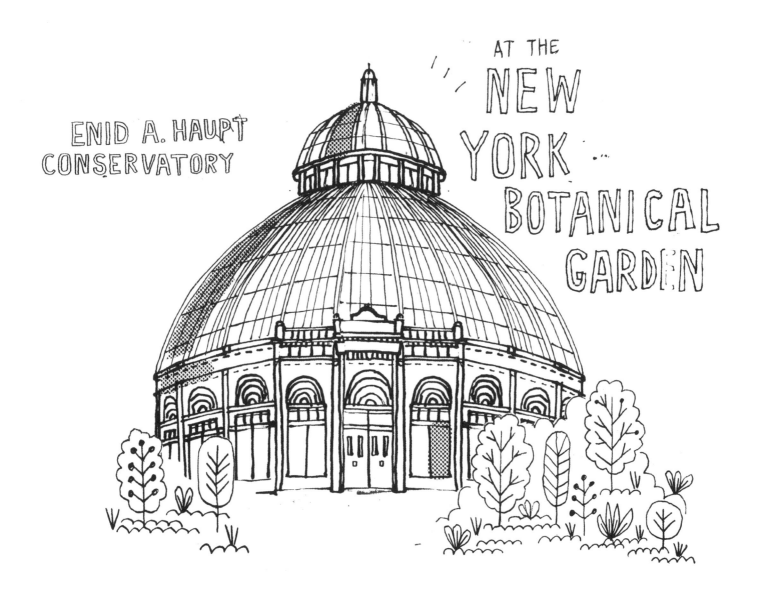

161-164 GRAND CONCOURSE

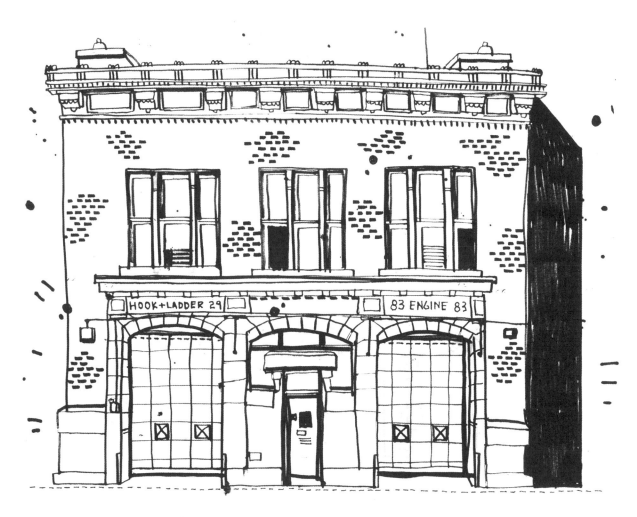

618 EAST 138TH ST.

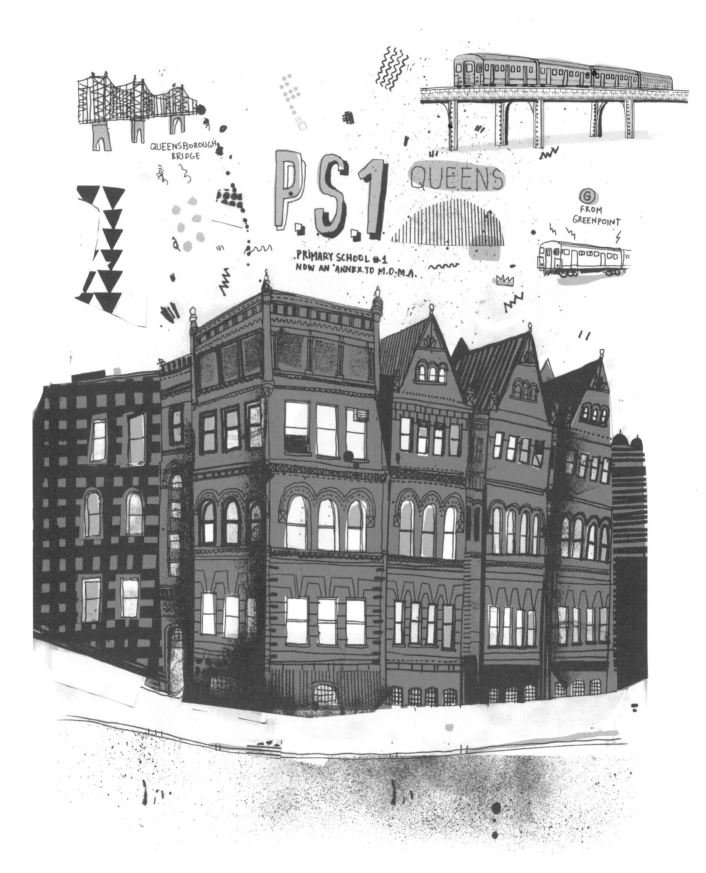

QUEENSBOROUGH BRIDGE

P.S.1
QUEENS

PRIMARY SCHOOL #1
NOW AN ANNEX TO M.O.M.A.

G
FROM GREENPOINT

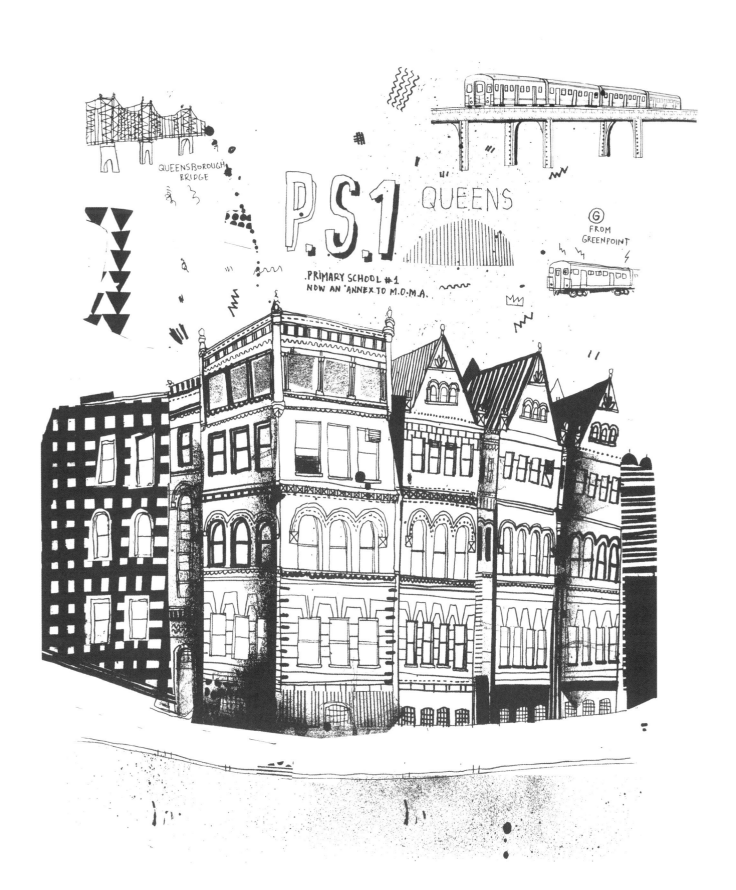

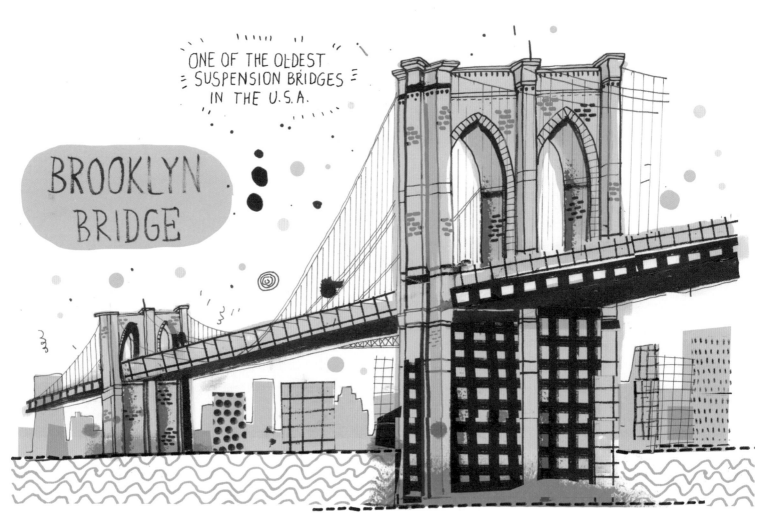

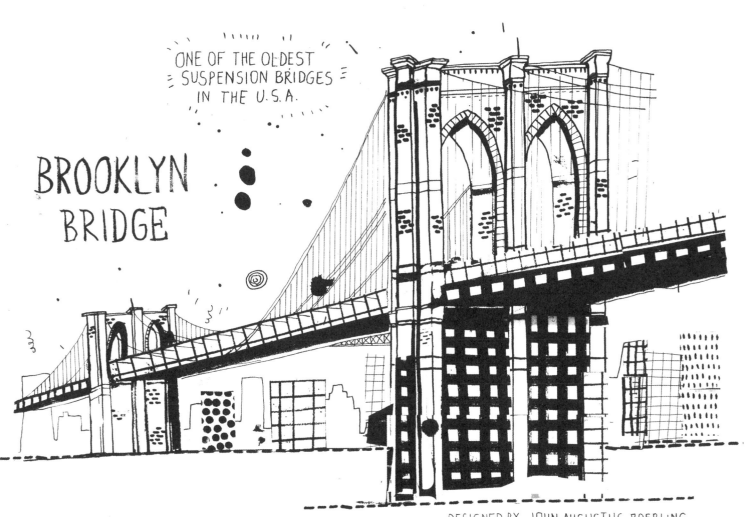

ONE OF THE OLDEST
SUSPENSION BRIDGES
IN THE U.S.A.

BROOKLYN
BRIDGE

DESIGNED BY JOHN AUGUSTUS ROEBLING
COMPLETED BY HIS SON IN 1883

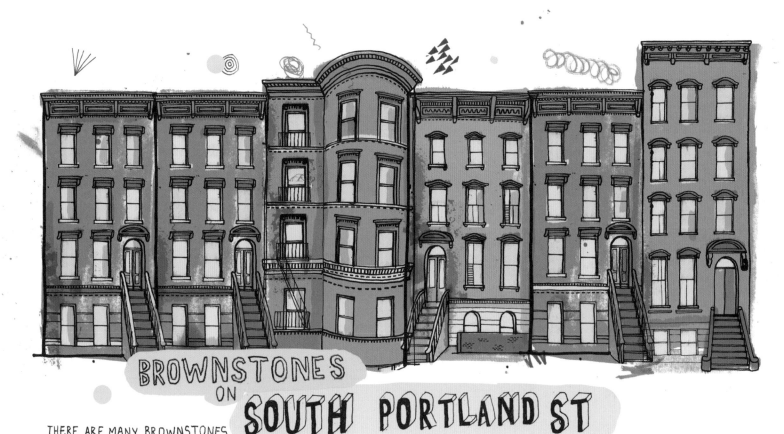

BROWNSTONES
ON SOUTH PORTLAND ST

THERE ARE MANY BROWNSTONES
IN NEW YORK CITY, ESPECIALLY IN BROOKLYN
NEIGHBORHOODS SUCH AS PARK SLOPE,
CLINTON HILL, FORT GREENE, COBBLE HILL,
AND BROOKLYN HEIGHTS. THEY ARE ELEGANT
ROW HOUSES FACED WITH A REDDISH-BROWN
SANDSTONE (ALSO CALLED BROWNSTONE), BUILT
FROM AROUND THE 1840s → 1900.

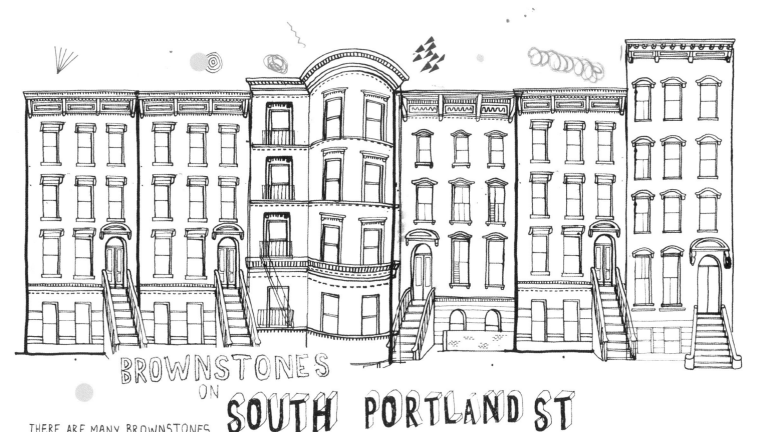

BROWNSTONES ON SOUTH PORTLAND ST

THERE ARE MANY BROWNSTONES IN NEW YORK CITY, ESPECIALLY IN BROOKLYN NEIGHBORHOODS SUCH AS PARK SLOPE, CLINTON HILL, FORT GREENE, COBBLE HILL, AND BROOKLYN HEIGHTS. THEY ARE ELEGANT ROW HOUSES FACED WITH A REDDISH-BROWN SANDSTONE (ALSO CALLED BROWNSTONE), BUILT FROM AROUND THE 1840s → 1900.

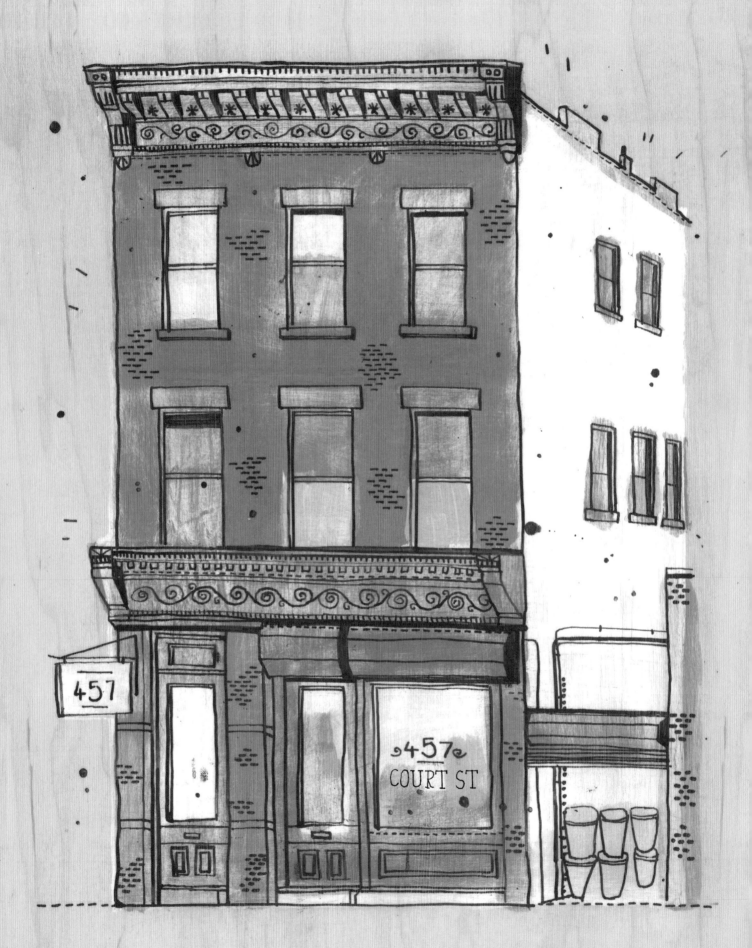

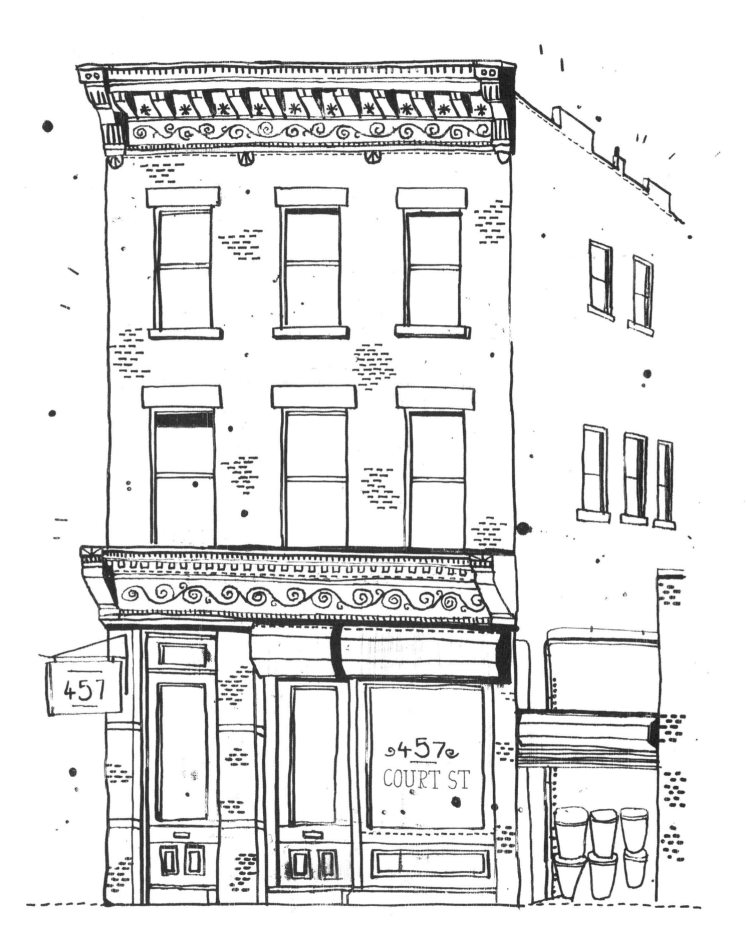

457
457 COURT ST

초판 1쇄 발행 2018년 10월 10일

지은이 | 제임스 걸리버 핸콕
옮긴이 | 김문주
발행인 | 홍경숙
발행처 | 책발전소

경영총괄 | 안경찬
기획편집 | 김효단, 박단비

출판등록 | 2008년 5월 2일 제2008-000221호
주소 | 서울 마포구 토정로 222, 201호 (한국출판콘텐츠센터)
주문전화 | 02-325-8901

표지 디자인 | 김종민
본문 디자인 | 김종민
지업사 | 월드페이퍼
인쇄 | 영신문화사

ISBN 979-11-89352-01-1 14650

* 책발전소는 위너스북의 실용 · 인문 브랜드입니다.
* 책값은 뒤표지에 있습니다.
* 잘못된 책이나 파손된 책은 구입하신 서점에서 교환해 드립니다.
* 위너스북에서는 출판을 원하시는 분, 좋은 출판 아이디어를 갖고 계신 분들의 문의를 기다리고 있습니다.
winnersbook@naver.com | Tel 02)325-8901

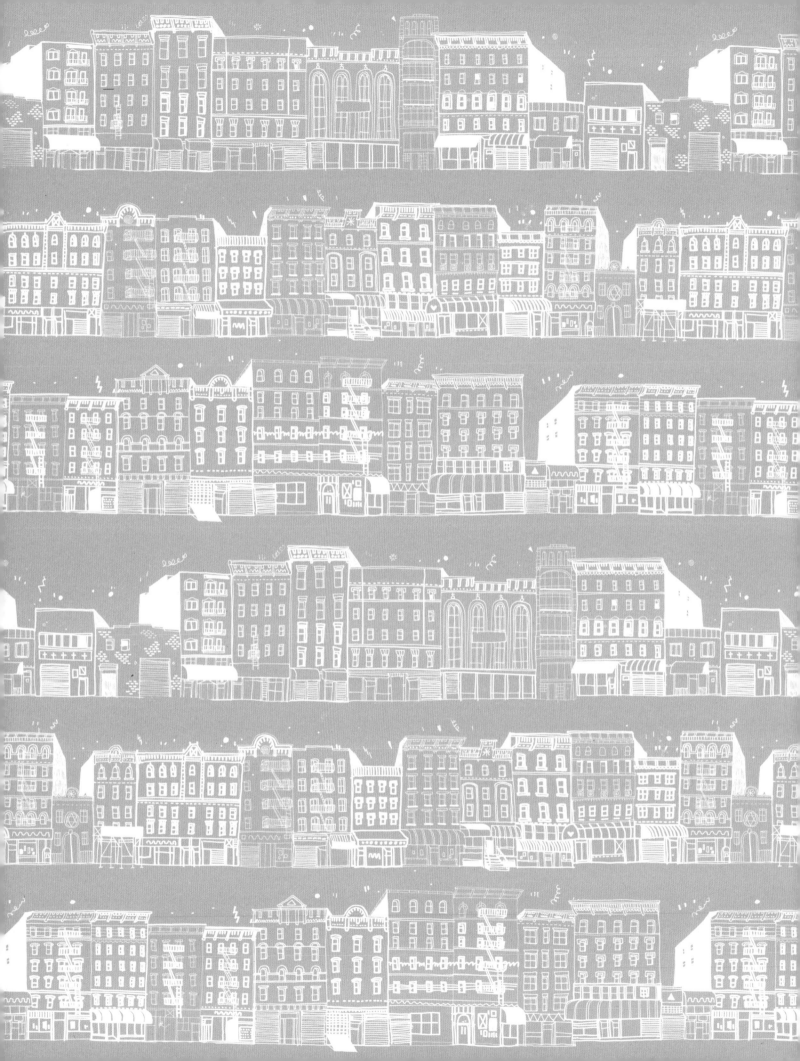